IMAGES
of America

KELSO

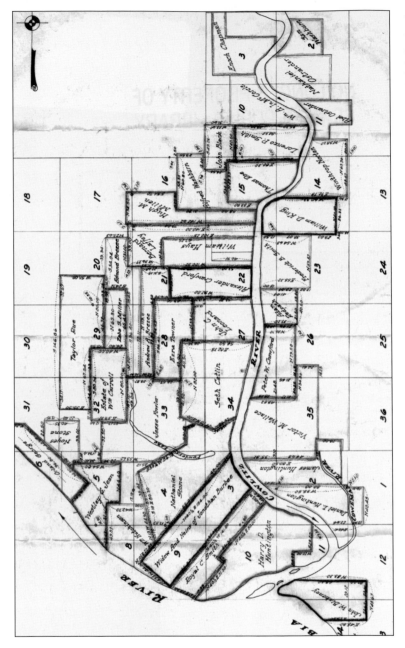

This map shows the donation land claims north from the mouth of the Cowlitz River in what would later be the Kelso and Longview areas. Earlier towns closer to the mouth of the Cowlitz—Monticello on the Harry D. Huntington Claim and Freeport on the Nathaniel Stone Claim—were mostly swept away by floods in the 1860s and 1870s. Kelso, begun on the first big hill on the east side of the Cowlitz on the Peter Crawford Claim, was better able to withstand the river's wrath. (Cowlitz County Historical Museum.)

IMAGES
of America

KELSO

George R. Miller, William R. Watson, and
the Cowlitz County Historical Museum

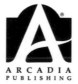

ARCADIA
PUBLISHING

Published by Arcadia Publishing
Charleston, South Carolina

Printed in the United States of America

Library of Congress Control Number: 2011925405

For all general information, please contact Arcadia Publishing:
Telephone 843-853-2070
Fax 843-853-0044
E-mail sales@arcadiapublishing.com
For customer service and orders:
Toll-Free 1-888-313-2665

Visit us on the Internet at www.arcadiapublishing.com

*This book is dedicated to the many individuals over almost 60
years whose thoughtful donations of documents, photographs,
and artifacts have made the Cowlitz County Historical Museum
a vital part of the town. Volunteers have given thousands
of hours in helping preserve those donations, and this book
would not have been possible without their dedication.*

CONTENTS

Acknowledgments

The staff at the Cowlitz County Historical Museum, including David Freece and Jim Elliott, has been most helpful with ideas and suggestions. The Arcadia editor initially assigned to the project, Donna Libert, and her successor, Tiffany Frary, have been there to answer questions regarding the publication. As always, Janice Miller, George Miller's wife, has been most helpful in proofreading documents. Without the help and guidance of these individuals, this project would not have been possible. All photographs are from the archives of the Cowlitz County Historical Museum.

INTRODUCTION

The recorded history of the area around Kelso, Washington, goes back to around 1800. On their way up the Columbia River, members of George Vancouver's 1792 expedition originally called the Cowlitz River "Knight's River." The Corps of Discovery passed downstream on the Columbia River in the fall of 1805 and returned upriver in the spring of 1806. It was this group's initial exploration that brought other explorers and trappers into and through the area. By canoe and bateau, they moved through the area from Fort Vancouver north to Fort Nisqually and Puget Sound. Even today, hundreds of thousands of people pass through what was and is known as the "Cowlitz Corridor."

This pathway through the area was first forged by foot travel over muddy trails and across creeks and rivers. Native Americans used these paths to travel north and south and east and west to trade their wares with other tribes. Following the Lewis and Clark Expedition, fur trappers arrived to obtain highly prized beaver pelts. Stories of the fabulous and bountiful Pacific Northwest soon found their way back to the mid and eastern sections of the country. This brought the settlers, farmers, and lumbermen.

From the late 1840s to the early 1860s, over 350,000 immigrants passed over the Oregon Trail into the Pacific Northwest. Several found homes in and around Kelso. The Cowlitz Corridor, thus, became a local "highway" for travelers and settlers. At first the rivers were used extensively, but as methods of transportation improved, roads were needed. This caused the demise of the steamboat era, but it opened up other methods of travel.

Interest in agriculture began to grow, and the fertile land in the delta of the Cowlitz soon was producing a multitude of crops that were exported via this corridor. Most of the land, however, needed to be cleared. Lumbermen from the East, whose forests had been mostly laid bare, heard of the tall, straight trees in the Pacific Northwest. Lumber soon became an important commodity and still is today, as logs are exported by the thousands through the Port of Longview. The area began to grow, and as it grew came the development of businesses, churches, and organizations.

The land and the waters passing though the Kelso area have had a profound effect on the town. As mentioned, the logging industry flourished, as did agriculture. And within the waters swam fish. Salmon, steelhead, and the eulachon (smelt) have all provided the area with jobs. Historical photographs show how plentiful these resources were in the past and, sorrowfully, how some have declined.

The Pacific Northwest, west of the Cascade Mountains, is somewhat noted for its rainy climate in the winter. And the rains do fall, sometimes in copious amounts. Thus, the rivers—mainly the Cowlitz as it passes directly through the town—have many times exceeded their banks over the years and inundated the local landscape. Some historic floods have resulted. However, one cannot forget the summers, which are generally warm and dry. The driest ones have caused major forest fires in the area.

Being in proximity to the Pacific Ocean, the area is subject to windstorms. Several have occurred, producing local damage. And there is Mount St. Helens. It erupted on May 18, 1980, and debris flowed down the Cowlitz River through the town. Of devastating effect then, the mountain today draws thousands of tourists into the area.

The history of the region is entwined in the preceding topics. Fortunately, a lot of that history has been recorded in photographs that are on file at the Cowlitz County Historical Museum. They are of excellent quality and tell the story of Kelso. A story we are sure you will enjoy reading.

One

THE TOWN
AND ITS PEOPLE

By 1925, Kelso, Washington, had grown to include a large section of the east bank of the Cowlitz River, as well as the former town of Catlin on the west bank, which was incorporated with Kelso in 1908. On the right side of the map can be seen the old meandering channel of the Coweeman River as it used to flow through South Kelso and its newly diked channel as it has flowed since. This old channel, some parts still sloughs in 1925, account for some of the "broken" streets in South Kelso, a bane to many an out-of-towner trying to find his way in that area. The town of Longview, begun by the Long-Bell Corporation in 1923, spreads out to the west of the Catlin area.

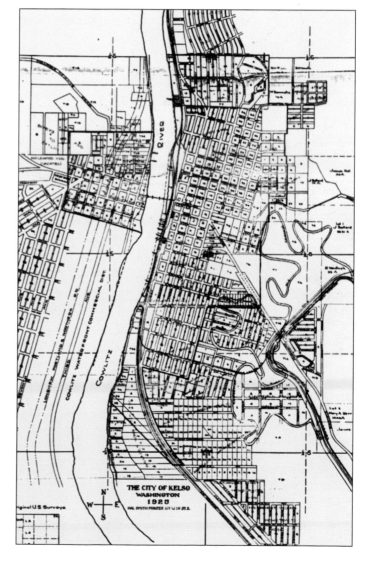

THE CITY OF KELSO
WASHINGTON
1925

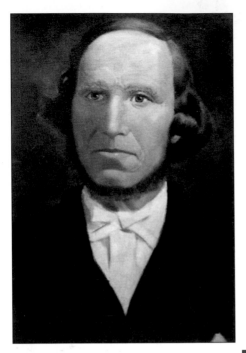

A native of Scotland's border country, Peter W. Crawford was an early Kelso pioneer and founder of the town. Crawford, born near Kelso, Scotland, in 1818, was educated at the University of Edinburgh, where he studied mathematics. He came to the United States in 1843 and, after a few years in Indiana, came to Oregon country in 1847. He staked the first donation land claim on the Cowlitz River in that year. A surveyor by trade, he was responsible for laying out many towns in northwest Oregon (Milwaukie, St. Helens, Rainier, Columbia City, and parts of Oregon City) and southwest Washington (Monticello, Vancouver, and Kelso). He served as an early justice of the peace and notary public and was a delegate to the Monticello Convention, which successfully petitioned Congress to separate what became Washington Territory from Oregon Territory. In 1884, he platted the town of Kelso on his land claim and named it for his hometown in Scotland. Crawford died in 1889. This portrait was painted by Evan Sharer in 1952 from a small photograph.

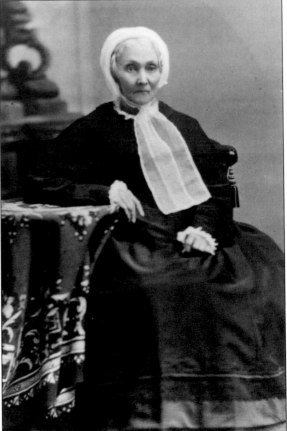

Agnes Redpath Catlin, also a Scotland native and born in 1806, came to the United States with her family in 1818, and they eventually settled in Illinois. In 1831, she married Seth Catlin, and they would have nine children, seven of whom survived into adulthood. In 1848, Seth moved the family west, eventually settling on the west bank of the Cowlitz River. In 1850, Agnes's brother Adam Redpath also came out west with his two sons and filed a donation claim on the land just north of Peter Crawford's. Known as the "Sage of Monticello," Seth was active in politics. Not only did he participate in the Monticello Convention but he was also elected president of the upper house in Washington's first territorial legislature. Seth died in 1865, and Agnes died in 1885, though several of their sons continued the family business in the area.

Dr. Nathaniel Ostrander was the first medical doctor to live in the area around Kelso. He and his family arrived in 1852 and settled on the east bank of the Cowlitz River north of Peter Crawford's claim. Ostrander was also a signer of the Monticello Convention and served as Cowlitz County's first probate judge. Several of his numerous children married children of early area settlers. The community of Ostrander, just north of Kelso, is named for him.

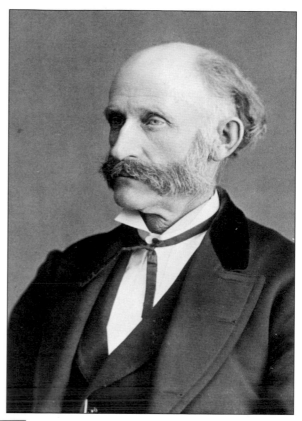

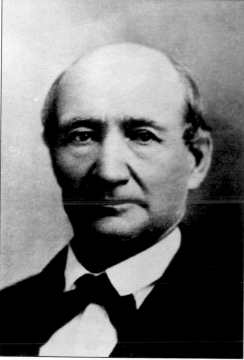

Born in Vermont in 1807, Victor M. Wallace brought his family to the Cowlitz Valley in 1850 and settled on a donation claim just south of Peter Crawford's. Trained as a cabinetmaker, he built grand homes here for himself and his sons' families out of the timber he cleared for his farm. He was a member and signer of the Monticello Convention and served as an early county treasurer and county commissioner. His 1895 obituary in the *Kelso Courier* described him as "a born genius of diversified talent, being equally at home in repairing and manufacturing pistols and guns, grist and saw mills, wagon and cabinet wares, while also an expert in the building of his own fine residence." His sons, Leander (Lee) and James, continued to farm his land until 1909, when they formed the Wallace Land Company to divide the area into home lots for new additions to Kelso. Most of Kelso south of Mill Street is in a Wallace addition to the town.

Oliff Olson (sometimes spelled Olif or Olaf Olsen) was born around 1833 in Sweden. His family sailed for America when he was a small boy, but a cholera epidemic on board killed most of his family before they reached New York. He eventually made his way to Illinois, where, at the age of 19, he joined a group of Huntington families who were heading west to join their brother Harry in the Cowlitz Valley. For several years, Olson transported goods up and down the Cowlitz, obtaining a river pilot's license and earning the title of captain. In the 1860s, he built a general merchandise store in Freeport, where he also served as postmaster. In the 1890s, Olson moved his store to Catlin (see page 19). He and his wife, Eunice Huntington Olson, had many children, who were also influential in the area. Olson died in 1920 and is buried in the Catlin Cemetery.

Henry Allen, seen here in his wheelchair around 1911, was one of Kelso's founding fathers and the man for whom Allen Street is named. He was born in England in 1834 and came to America in time to fight for the Union during the Civil War. In the 1870s, he came to the Kelso area, where he built his residence in what would be the original town of Kelso, at Allen Street and Third Avenue. In the 1890s, he suffered a severe illness, which caused him to be wheelchair-bound for the rest of his life. Even so, he remained active in several clubs, especially the Grand Army of the Republic (see page 77) and the Odd Fellows lodge. He died in 1921 and was interred in Kelso's Odd Fellows Cemetery, now called Cowlitz View Memorial Gardens Cemetery.

Charles Henry Davolt, seen here around 1890, was the eldest son of William L. and Catherine Davolt, who came to the area in 1874. Being involved in church and civic activities, the many Davolt children were prominent citizens in Freeport, Catlin, and Kelso.

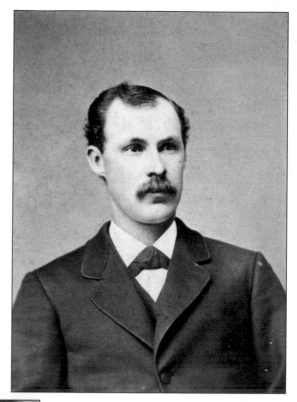

Judge Daniel Kelley—seen here with his second wife, Jane Kleaver Kelley—was born in County Cork, Ireland, in 1825 and immigrated to America as a young man. After many years in Illinois, California, and Nevada, he came to this area in 1884. In 1888, he moved to Kelso and worked selling town plots for William P. Crawford, a son of Peter Crawford. In 1890, Kelley was admitted to the state bar and became a justice of the peace and Kelso's police judge. He also served several years on the Kelso School Board. His 1908 obituary in the *Twice a Week Kelsonian* states, "He was held in the highest esteem by all, and his death has come as a great blow to those who have known him and have worked with him in the upbuilding of the town and the preservation of law and order in this community."

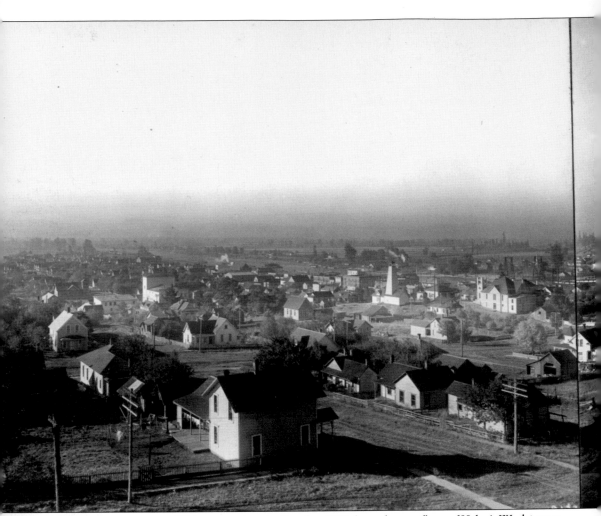

This panoramic view of Kelso was taken in October 1911 from the top floor of Kelso's Washington School on Columbia Street (see page 63). The view to the left looks southwest, while that to the

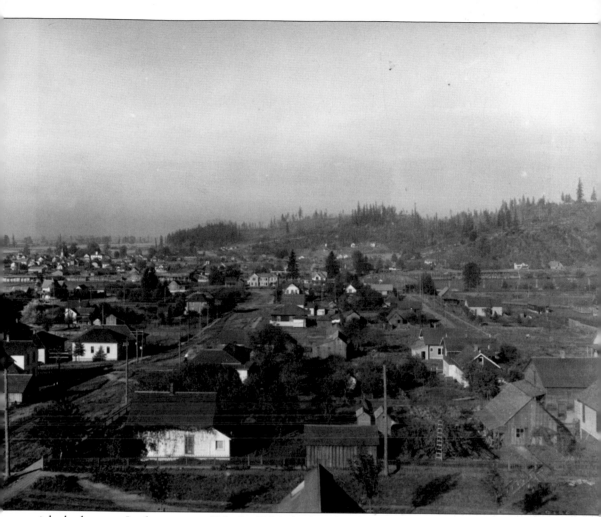

right looks west. In the center is Kelso's old Methodist church, with the city fire tower to its left and the lift span towers of the second Allen Street Bridge seen above it.

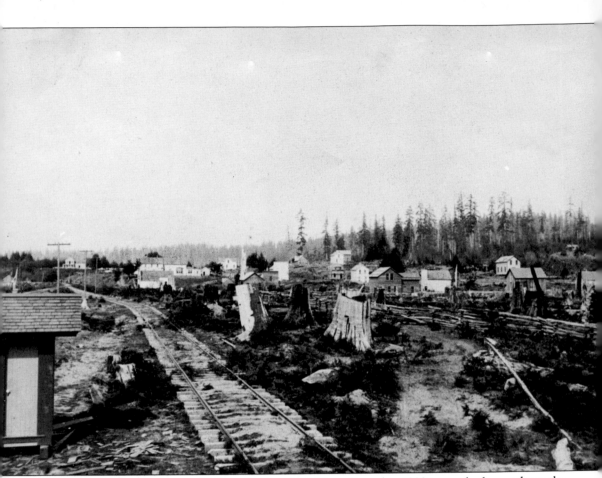

One of the earliest views of Kelso after its official founding, this 1888 image looks north up the Northern Pacific Railroad tracks from around where the train depot is today. On the hill in the background, to the left, is Peter Crawford's house, which had to be moved when the railroad came through in 1872.

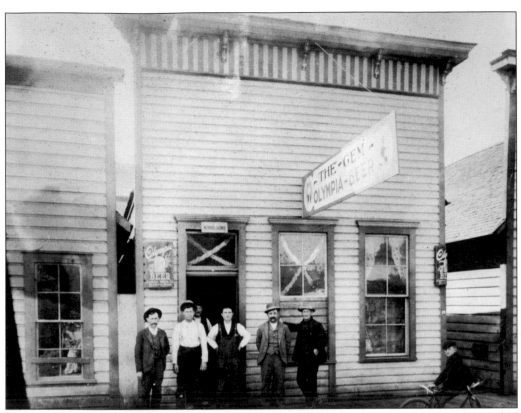

Being a timber town, Kelso had no shortage of saloons and taverns at which the loggers could slake their thirsts on weekends. The Gem Saloon, shown above about 1900, was on the south side of Allen Street near the corner of Pacific Avenue (Second Avenue at that time). The five men standing in front are, from left to right, Eddie Green, George Secor, Dick Stoves, Al Secor, and Tommy Calahan. Inside the Old Corner Saloon (below, see page 23 also) owned by Mark Swager, James Davolt is behind the bar ready to serve his customers.

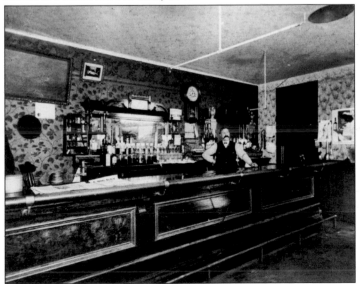

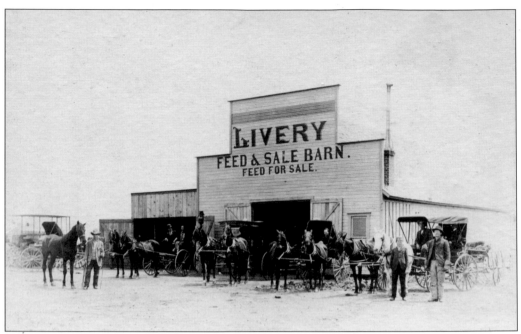

The Kelso Livery Stable, located at 100 Pine Street, is seen here in the 1890s. It was one of several liveries that provided horse boarding, rentals, and sales for town residents. That site today is the home of the Maltese Tavern.

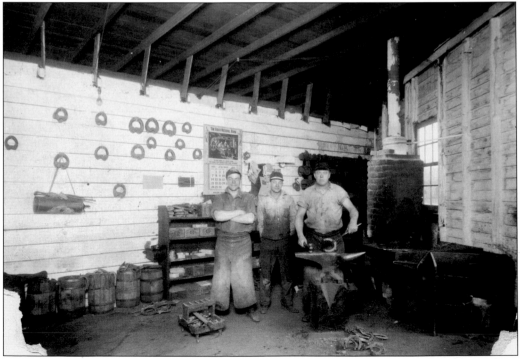

As late as 1925, there was still a high demand for blacksmithing services in Kelso. These three workers are making horseshoes in Jack Murphy's Blacksmith Shop at 602 Ash Street. There are residences there now.

"Grandpa" J.G. Jones (right) became Kelso's mayor after the city's second incorporation in 1894. He is seen here, in his general store on First Avenue, with Mary Jones behind the counter.

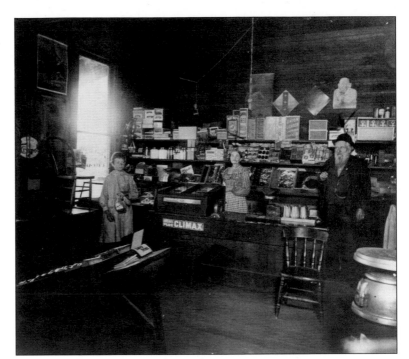

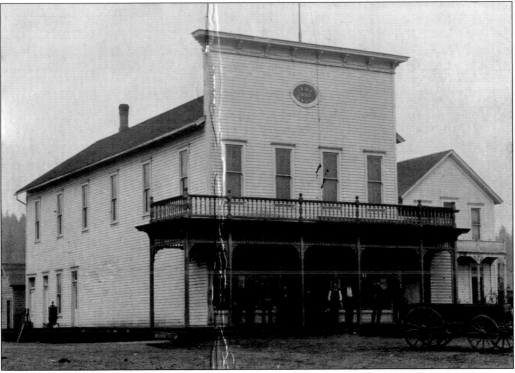

Oliff Olson's store, built in Catlin in 1895, was at the corner of Main Street and First Avenue, where the West Kelso Flying K is now. Its second floor was used as a meeting hall for organizations, such as the Masons and Odd Fellows, and for dances. The house next to it belonged to Orrin Hinson, Catlin's first postmaster.

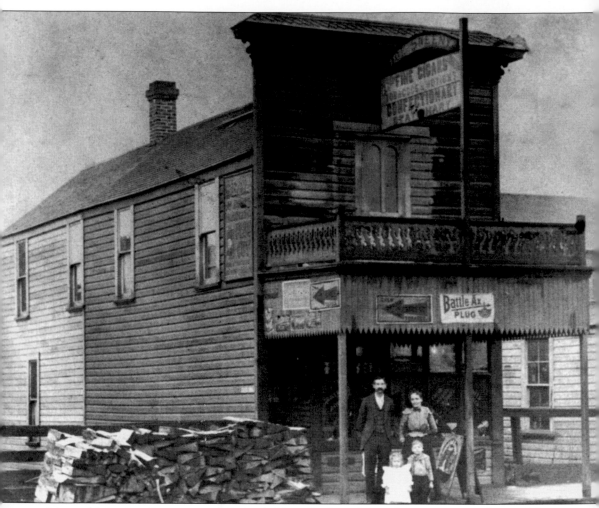

Mr. and Mrs. Joe Sweeney and their children Ruth and Joseph are posing in front of their confectionery store on Oak Street in Kelso, just east of Allen Street, around 1900. Confectionery stores, as they were called, were very popular in the late 1800s and early 1900s, providing candies and other sweets.

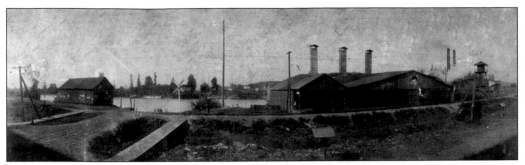

This wide-angle c. 1900 view shows the Allen Street railroad crossing leading down to the ferry landing. On the right is the Duff Shingle Mill, which burned in 1902 and was replaced by the Crescent Shingle Mill (see pages 49 and 122). The first bridge across the Cowlitz at Kelso was built in 1904.

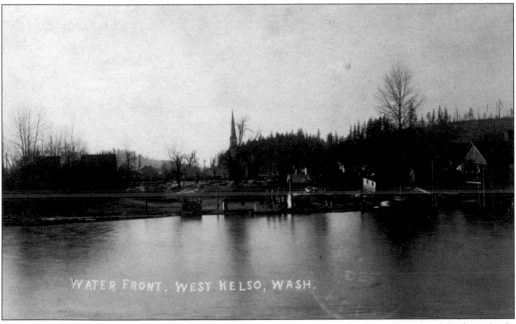

WATER FRONT, WEST KELSO, WASH.

This view of the West Kelso waterfront, taken about 1909, shows the former town of Catlin a little bit south of the Allen Street Bridge, about where the Cowlitz County Hall of Justice is today.

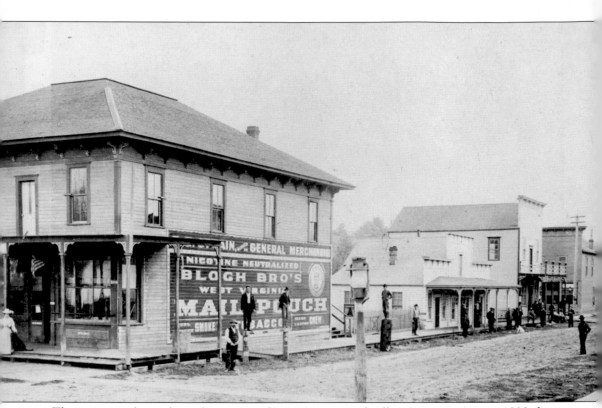

This view northeast from the corner of First Avenue and Allen Street in August 1898 shows the Buford & Strain Store run by J.P. Buford and Scott Strain on the corner at left. The second floor of the building, known as Strain's Hall, was used for parties, socials, dances, and traveling shows and included an elevated stage with curtain and side wings, dressing rooms, and a ticket office. The store would go on to have many subsequent proprietors, including Strain and Laurie; Laurie, Hogg, and Clay; and Rulifson and McKenney. Beyond the picket fence is Judge Kelley's home and office. The two-story building with the balcony in the background on the right is Gumm's Saloon.

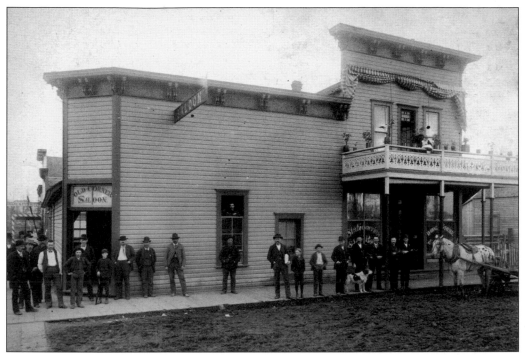

On the southeast corner of First Avenue and Allen Street sat the Old Corner Saloon owned by Mark Swager. Behind it on South First Avenue was Dunham's Drugstore. In this photograph, Marcus Swager is the 4th man from the left (in white shirt and vest), James ("Jim") Davolt is 12th in from the left (in the window), and Harry Dunham is the 18th man from the left (just to the left of the first post). On the balcony, Eliza Spencer Morton is holding two-year-old Inez Swager. The saloon building was renovated several times over the years and eventually had a brick facade as the Blue Ox Tavern before it was razed in the 1960s.

In 1906, Kelso saw one of its first automobiles, shown here outside the Kelso Art Gallery of Elbert Springer. The men in the car are Kelso members of the Vancouver Elks Lodge, the nearest local Elks lodge at that time. From left to right are Louis Plamondon, Albert Burcham, William Lyons, Fred L. Stewart, William Wesley "Dick" Stoves, Dr. Floyd A. Bird, and Frank Hull. The small boy looking at the car is Frank Remick.

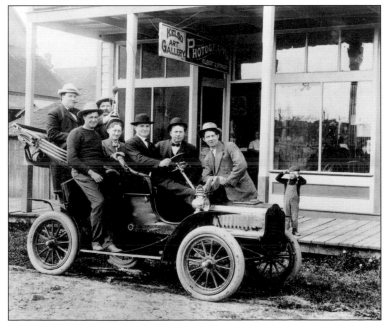

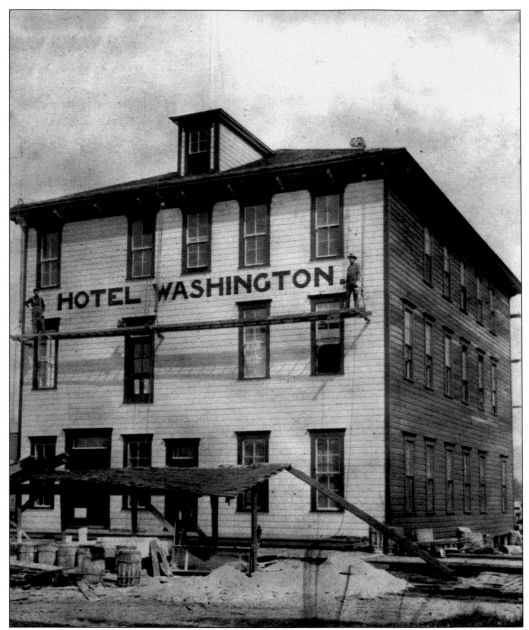

About 1900, Henry Morris's Hotel Washington on South Second Avenue (now South Pacific) burned down. To replace it, he purchased an existing hotel in Columbia City, Oregon, and floated it to Kelso over the Columbia and up the Cowlitz Rivers during high water. This picture was taken not long after the move. The hotel was a large one and took up half a city block, running between South First and South Pacific Avenues, next to Vine Street. It was torn down in 1939 to make way for a new, larger Safeway store. Today, it is the site of the city's new unemployment office.

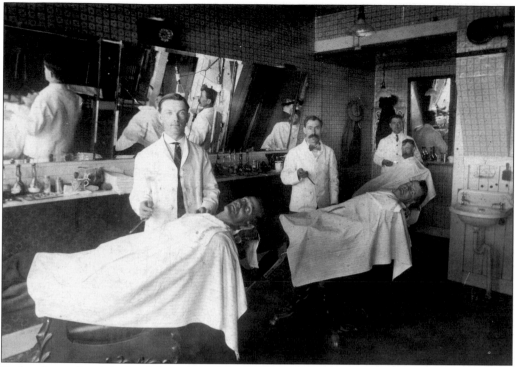

Barbershops also did a brisk business when the loggers came to town. One shop, seen here in 1909, featured barbers Jack Hill (left), George Beidleman (center), and Bert Hunt.

For those less disposed to alcoholic beverages, a stop on Pacific Avenue at the Luther Short Ice Cream Parlor in the 1910s would yield a cold, savory treat.

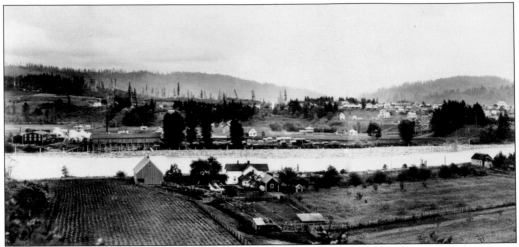

This panoramic view east from the Catlin Cemetery in 1910 shows farmland in northern West Kelso and, across the Cowlitz River, the houses and mills of North Kelso.

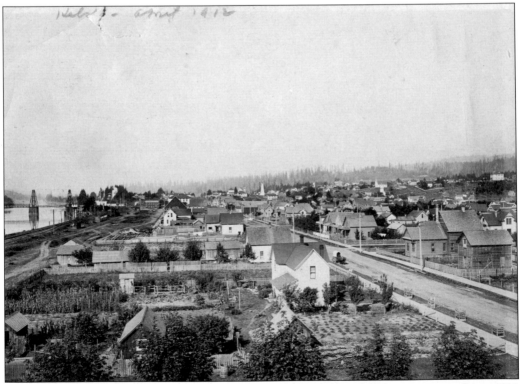

Home gardens were the norm in the new Wallace additions of South Kelso, as seen in this c. 1912 view north from around Chestnut Street. In the background on the left is the second Allen Street Bridge. In the background center is the city fire tower. On the far right in the background is the Academy (see page 63).

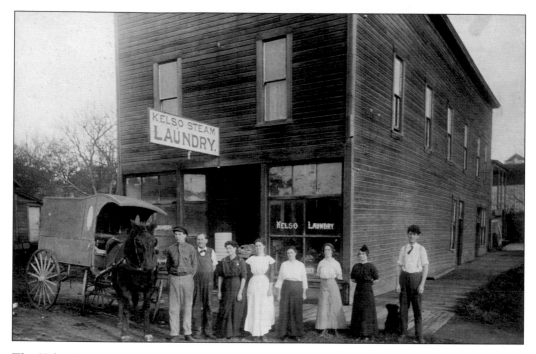

The Kelso Steam Laundry (above), seen here about 1910, was one of the first in town to use machine cleaning for some processes. More than a decade later, in October 1926, Robert Bodgess (below) began using a Model T delivery truck to advertise his Blue Bell Pantorium laundry and tailoring services.

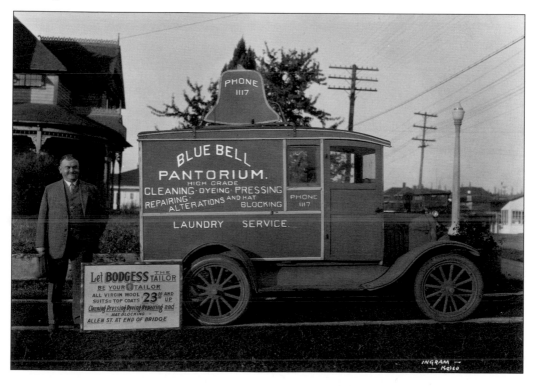

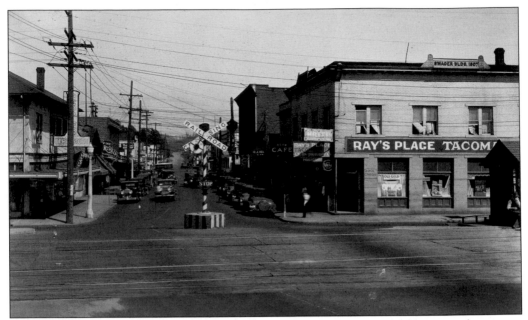

Waiting to direct traffic at the railroad crossing, a flagman sits at the signal house at the eastern foot of the Allen Street Bridge in the late 1920s. A view down Allen Street in the background shows several businesses at the time, including Ray's Place (a tavern), Peoples Department Store, Club Café, Arcade Rooms, Farmer's Market Meats, Idle Hour Cigar Store, and Mottman's Department Store.

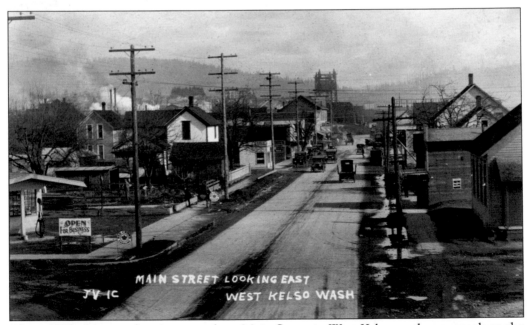

About 1925, this was the view east along Main Street in West Kelso on the approach to the Allen Street Bridge.

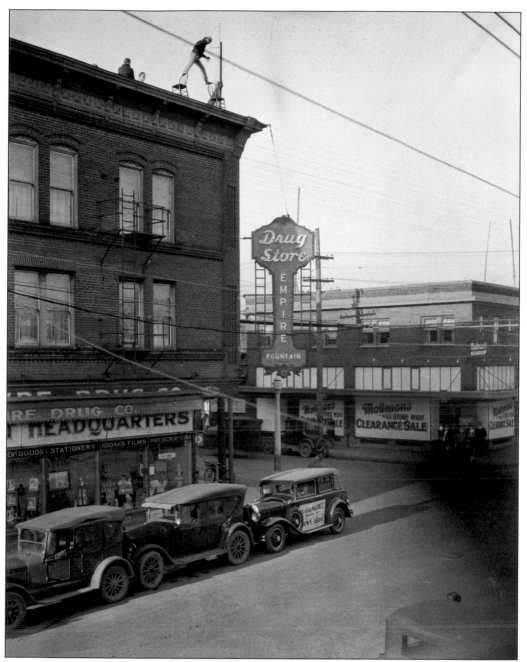

In 1929, the Empire Drug Co. building on the southwest corner of Pacific Avenue and Allen Street became the stage for the daring stunts of vaudeville performer "The Great Maurice" (see also page 35). A small crowd gathered to watch across Allen Street at Mottman's Department Store.

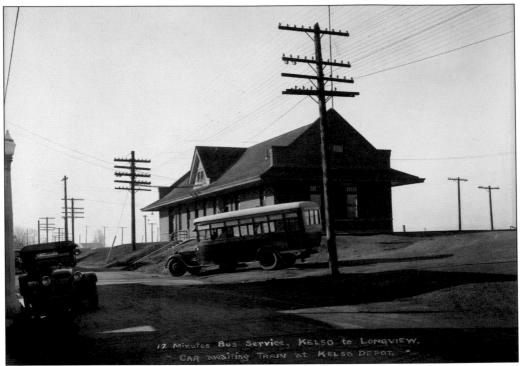

12 Minutes Bus Service, KELSO to LONGVIEW.
- CAR awaiting TRAIN at KELSO DEPOT.

Three years after the founding of Longview, a Longview Public Service Company bus awaits travelers at the Kelso Railroad Depot at the foot of Ash Street. Though Longview had its own railroad station and rail line by this time, the LP&N (Longview, Portland and Northern Railway) trains were the only ones that crossed the Cowlitz River. The bigger rail companies, like Great Northern and Union Pacific, kept to the tracks on the east side of the river—the ones that went through Kelso.

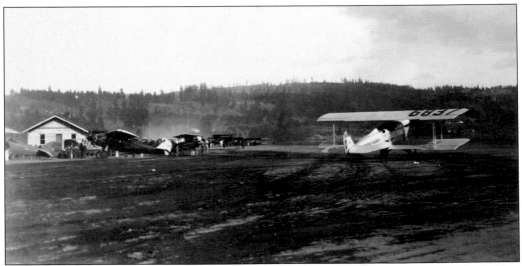

Built on former farmland in South Kelso, the Kelso Airport opened officially in 1930. This photograph from the early 1930s shows it was well used, both for student training flights and small commercial flights by the Columbia Empire Flying Service.

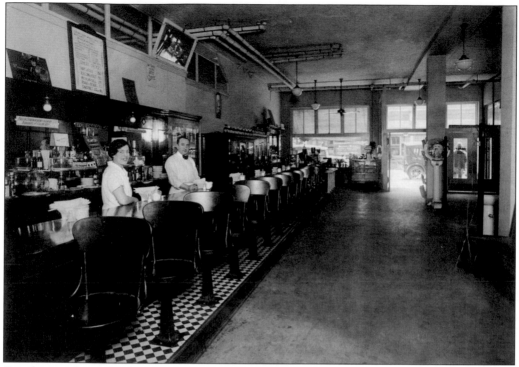

Seen here in the 1930s, the Terminal Café, located at the Kelso Bus Terminal on South First Avenue between Pine and Ash Streets, was owned and run by John ("Don") Maritsas and John Lee.

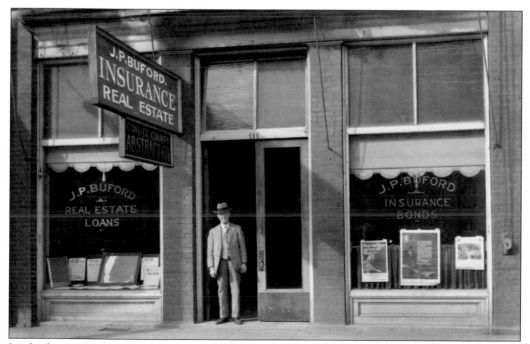

In the late 1920s, J.P. Buford stands in the doorway of his Cowlitz County Abstract Company insurance and real estate office at 111 Oak Street.

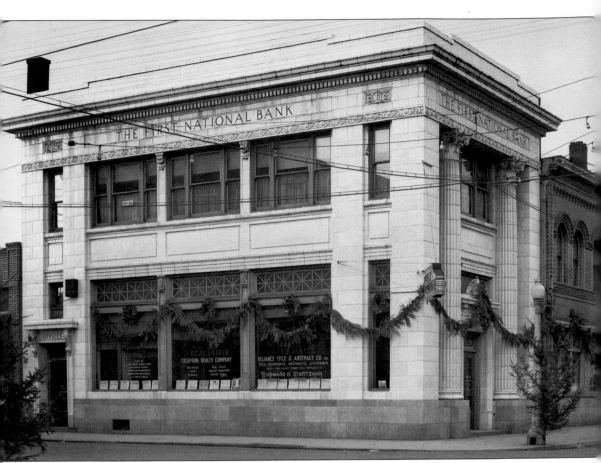

This December 18, 1937, photograph shows the Kelso First National Bank building, on the corner of Oak Street and Pacific Avenue, already decorated for Christmas. The Kelso First National Bank, begun by Scott Strain in 1907, was Kelso's second bank but its first with a national charter. The building was erected in 1907. In 1931, Kelso First National Bank closed its doors for good due to mismanagement by its president, Clyde C. Bashor. After that, the structure became the new home of the Cowlitz Valley Bank, which had been started in 1921 by a group of local investors. Cowlitz Valley Bank was later taken over by Seattle First National Bank, which in turn was acquired by Bank of America. The building itself was closed in 1946 and demolished in the early 1970s, and Kelso Commons Mini-Park was dedicated at the site in 1976.

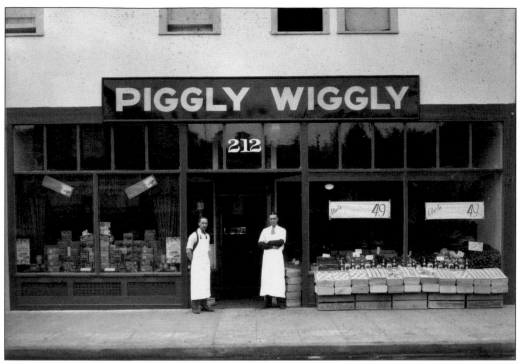

Prior to the 1930s, all grocery stores in Kelso were locally owned and operated. The Piggly Wiggly (above) became the first chain store in town when the company opened a location at 212 Allen Street. On March 6, 1937, the new Kelso Safeway (below) had its grand opening on Oak Street, drawing large crowds with its bargain prices. Two years later, Safeway moved into a bigger building on South Pacific Avenue, where the Hotel Washington had been.

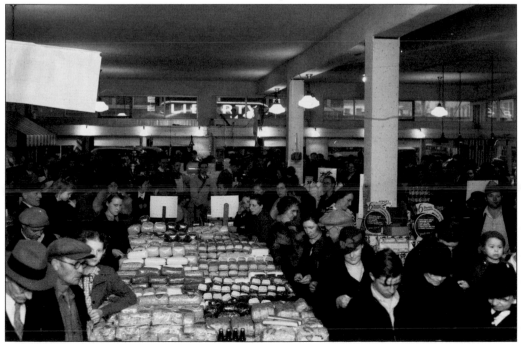

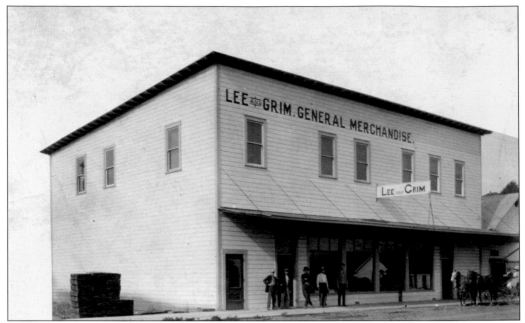

From around 1910 (when the above picture was taken) through the 1940s, the Lee and Grim store served the general merchandise needs of the Kelso public. It was located on the north side of Allen Street between Fourth and Fifth Avenues. The building was eventually torn down and replaced with offices, which, after remodeling, were turned into the Cowlitz County Historical Museum in the late 1970s. The photograph below shows the museum in the 1980s. It has since been renovated again.

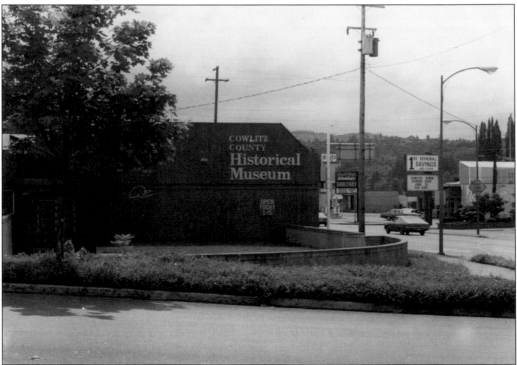

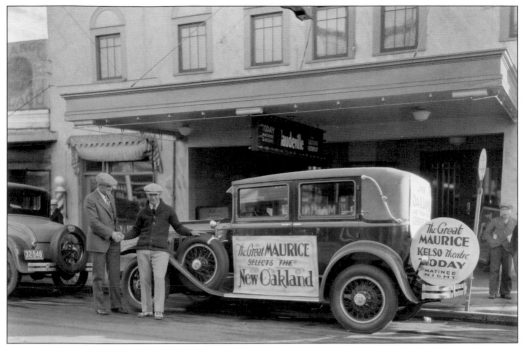

In the early 20th century, Kelso had three theaters for plays, vaudeville shows, lectures, and, later, movies. The Kelso Theatre (above in 1929, with The Great Maurice outside) at Pacific Avenue and Vine Street is the only one still in use. Early on, it was known as the Vogue Theatre, and today, several renovations later, it is the Kelso Theatre Pub. The Liberty Theatre (below) on Oak Street was the setting for a December 1940 food drive by the Kelso Antler Club. Food was the price of admission.

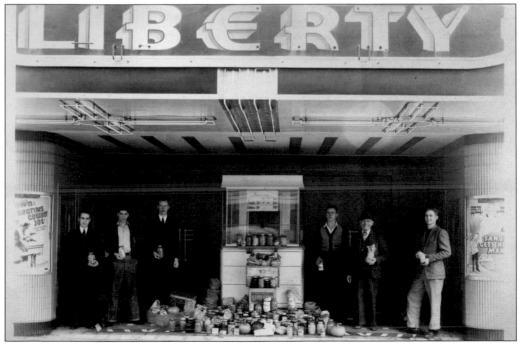

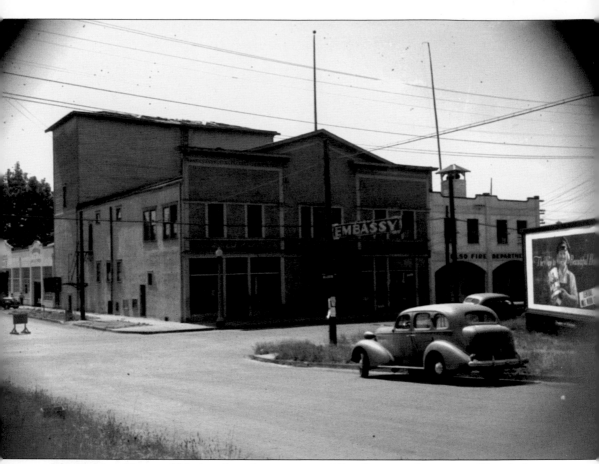

The Embassy Theatre, Kelso's earliest theater, was on Allen Street on the corner of Fourth Avenue, as seen here around 1938. For many years, Kelso High School's student plays were presented at the Embassy.

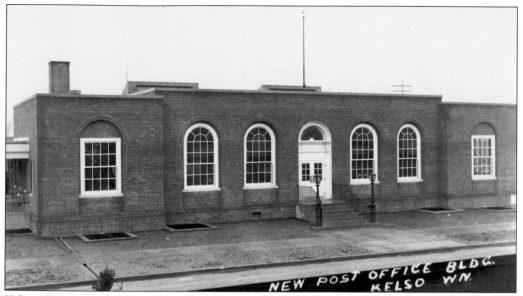

Kelso's first federally constructed post office was erected as part of the government's New Deal building programs in 1935. It is seen here soon after it officially opened on January 2, 1936. It is still in operation at this location on Academy Street.

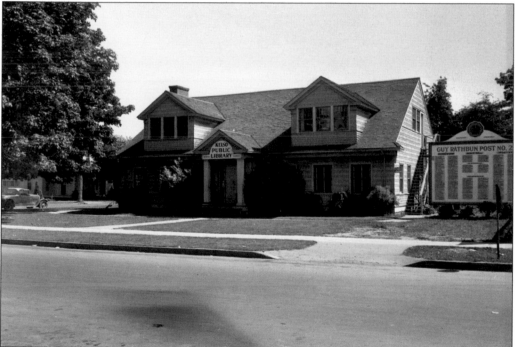

In the late 1930s, the former Kelso Club, a civic meeting hall on Oak Street between South Third and Fourth Avenues, was converted into the Kelso Public Library, seen here in 1939. The sign to the right is for the Kelso chapter of the American Legion, named for Guy Rathbun, a Kelso man killed in World War I. The library was later relocated up Fourth Avenue to a building next to the post office and, in 2011, is moving into the Three Rivers Mall. The Kelso Club itself was torn down, and that site is now home to the Kelso True Value.

Don Talley (second from left), seen here at an area celebration in the mid-1950s with Longview mayor H.R. Nichols (in the derby hat), was a longtime Kelso mayor, as well as a state senator. He served as Kelso's mayor from 1953 through 1968 and was a state senator from Kelso's district from 1956 to 1983. For his many efforts on behalf of the city, Talley Way in South Kelso's industrial park was named for him.

Two

WORKING THE LAND
AND THE RIVERS

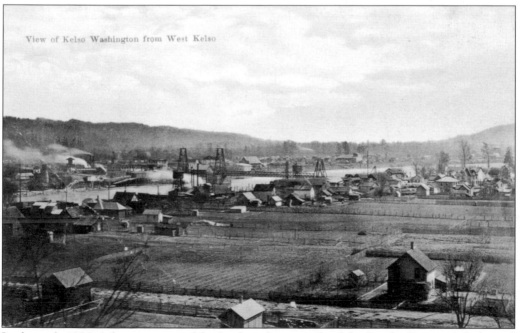

In the early 1900s, a large portion of the land on the west side of the Cowlitz River was dedicated to agriculture, as this photograph taken from Goat Hill (now known as Park Hill) shows. Today, it is filled with homes and businesses.

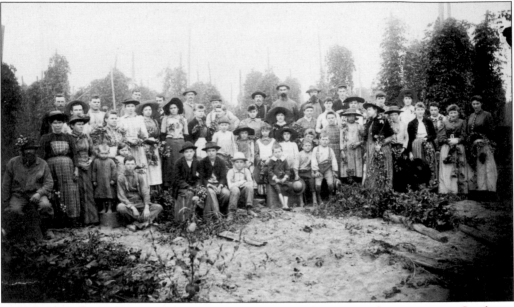

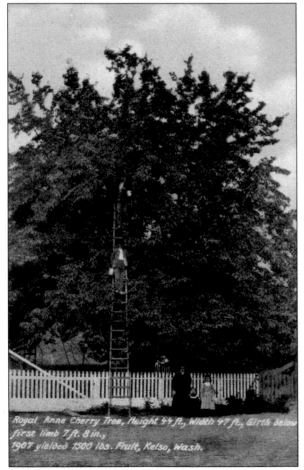

Royal Anne Cherry Tree, Height 44 ft., Width 47 ft., Girth below first limb 7 ft. 8 in., 1907 yielded 1500 lbs. Fruit, Kelso, Wash.

Hops were a favorite crop in Cowlitz County, as this photograph of Inman's hop yard shows on September 12, 1892. The Inman hop yard was the first in Cowlitz County, situated in the farmland west of Kelso, in what used to be Freeport. There were also several large hop yards in the Ostrander and Olequa (north of Castle Rock) areas, as well as around Woodland. Because hops required more hand labor than any farm crop grown at that time, whole families would be employed to pick the crop, and it was a decent way for women and children to earn money. A 10-acre field would employ 50 to 60 pickers for two weeks. With the coming of Prohibition in 1920, hop yards became unprofitable, and local production ceased.

Fruit trees were also plentiful in the rich Kelso agricultural area. This Royal Ann cherry tree was 44 feet high and 47 feet wide. The girth below the first limb was seven feet, eight inches, and it yielded 1,500 pounds of sweet cherries in 1907, the year this picture was taken. This tree was on the farm of S.J. Beck in Lexington.

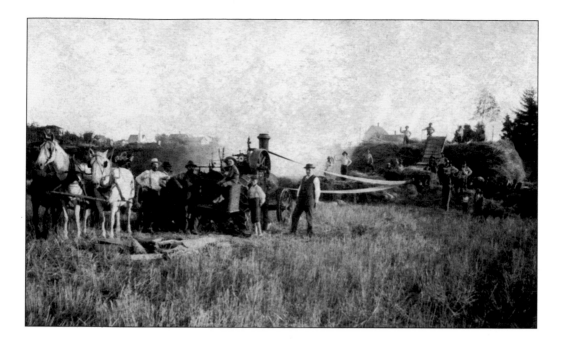

Steam threshers were popular in the early 1900s. The actual threshing process was carried out far behind the steam engine to prevent fires. Water wagons were located close by and were often pulled along by horses. The photograph below shows the water wagons being pulled by the steam engine driven by Charles Henry Davolt (left). In the early 1900s, Davolt owned the only threshing machine in the area and made a business out of its use at local farms. Also on the tractor are Elmer Huntington and Lou Dorrence (standing).

This photograph shows the Martin Nelson farm located north of Kelso near Ostrander. Emma Davolt Nelson is shown sitting in the buggy. The man on the horse is unidentified. Most farmers in the area had at least a few dairy cows, and dairying became a big business in the first decades of the 20th century, reaching its peak (in the number of farmers) in the mid-1930s.

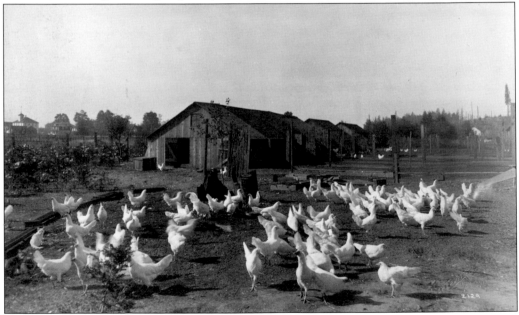

J.C. Patton owned a chicken ranch, seen here in 1911, on the west bank of the Cowlitz River and just north of Catlin. Smaller farms closer to the city center were more suited to raising poultry and small crops rather than livestock or large-field crops.

Fertile bottomland for raising crops and livestock was also present between where the Coweeman River met with the Cowlitz in what is now South Kelso. Mary McGowan Bloyd's parents farmed this land from the 1880s into the early 1900s. This photograph shows one of their pastures, with a fenced orchard in the background.

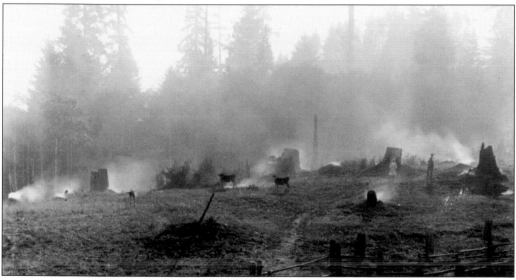

With the land heavily forested when the first settlers arrived—except for bottomland next to the rivers—the stumps had to be removed once the trees were cut. This was done by "char-pitting" the stumps. The process is described in a 1912 Kelso promotional brochure: "By 'char-pitting' is meant the slow burning of the stumps after the manner of the charcoal pit. Around the stump is built a circle of fire, which is covered and kept burning in this way until the stump is entirely consumed. This method is slow, but by this means it is possible for a man to clear land with no investment other than his time. . . . [T]he soil is actually improved by the potash and other chemical elements released by the burning of the stump." Other methods included horses and a crude machine and simply digging them out. This photograph of burning stumps was taken on the Towne farm near Carrolls, south of Kelso, around 1910.

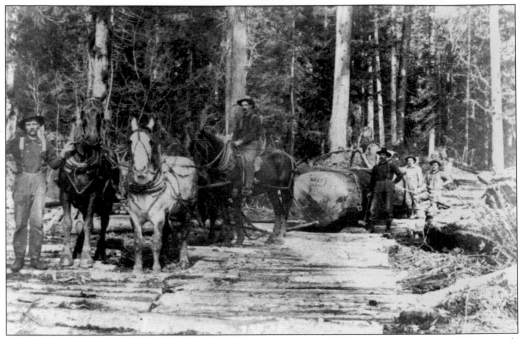

Horses were used to remove the large logs from the forest on skid roads, as this 1890s photograph of the Holbrook Brothers Logging operation in the Rose Valley area shows. Eli D. Holbrook is shown at the far left, and Henry Holbrook is standing next to the log in the background. The man on the horse is Jess Holbrook.

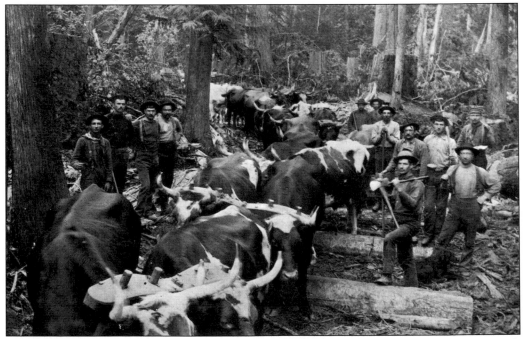

Oxen were also used to pull large logs from the forest along skid roads to sawmills. This photograph was taken in the Ostrander area in 1888. Some early area mills had large herds of oxen for this use and employed blacksmiths to make ox shoes to protect their hooves.

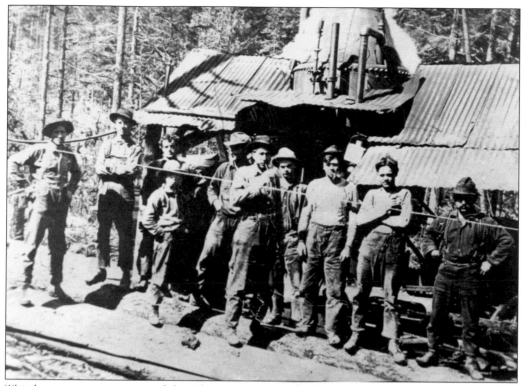

This logging crew was part of the Algers Company, which ran a sawmill on Mulholland Creek on the upper Coweeman River about 25 miles east of Kelso. Dale Rarey (second from right) was a whistle punk with the company. A whistle punk, a beginner's job on a logging crew, was the man or boy who passed signals from the rigging slinger or choker setter (guy attaching the cable to the logs) to the steam donkey engineer so that the timber could be yarded out from where it was cut.

The R.H. Barr logging operation on the Coweeman River, east of Kelso, built several large splash dams like this one on the waterway, seen here in 1898. Splash dams were used to build up a head of water so that a large quantity of logs could be placed below the dam and then moved downstream en masse when the water was released from the gates.

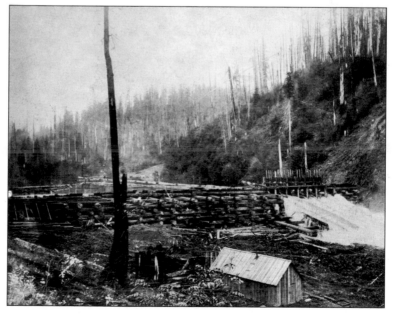

This 217-foot-long flagpole intended for use at the Lewis and Clark Centennial Exposition in Portland in 1905 was cut by the Ostrander Railway and Timber Company mill on Ostrander Creek. The pole was so long that suitable railcars could not be found to transport it to Portland, and the timber ended up rotting alongside the rail line. The Ostrander Railway and Timber Company mill (see page 51), begun by Everell S. Collins in the 1890s, produced some of the longest milled timbers in the world. Regular shipments of timbers over 100 feet long were used for ship masts and keels or for construction of Mississippi River barges, among other things. The mill at Ostrander closed in the late 1930s.

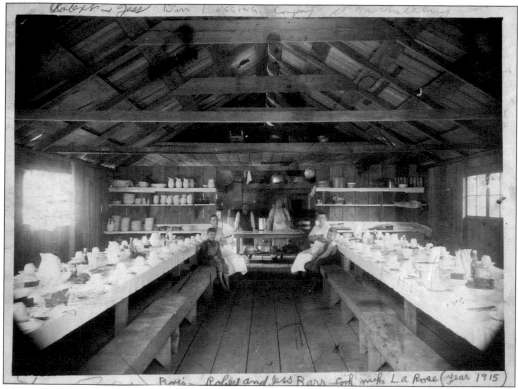

The Barr Logging Company, shown in an earlier photograph, maintained a cookhouse just below the dam on Mulholland Creek in 1915. The two boys in the photograph are Robert (left) and Jess Barr. The cook behind the counter is Mike LaRose. The other individuals are unidentified.

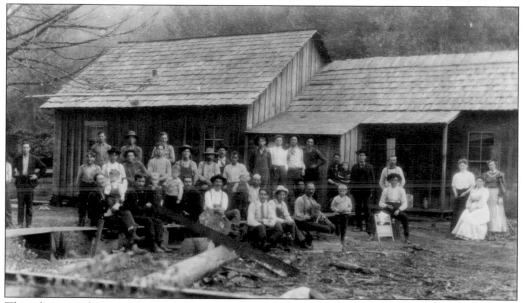

This photograph shows S.J. Beck's Logging Camp crew and staff in 1907. The camp was located in the vicinity of Lexington, about five miles north of West Kelso on the west side of the Cowlitz River. From this camp, logs were transported to Beck's Mill on the Cowlitz River.

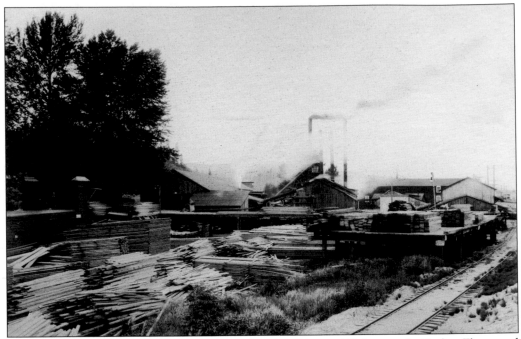

Another one of the many lumber mills located in the vicinity of Kelso was the Bashor-Fleetwood Mill located in North Kelso on Donation Street. In this c. 1910 image, lumber is seen on the loading dock next to the railroad, while additional lumber, to the left, is waiting to be kiln dried.

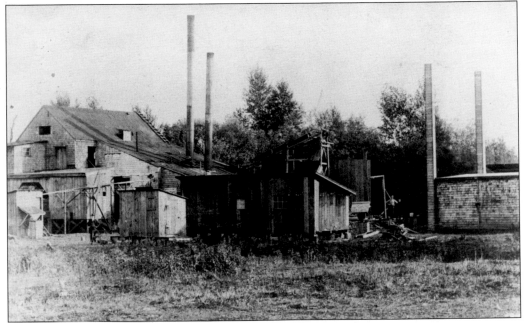

In the first decade of the 20th century, Kelso boasted up to 10 lumber and shingle mills from its northern limits to the mouth of the Cowlitz, on both sides of the river. The Cagwin (also spelled Coquin) Shingle Mill, seen here around 1909, was located at the end of Mill Street between the Cowlitz River and the railroad tracks. Previously, this mill had been known as the Washington Red Cedar Shingle Mill. It was common for a mill's name to change with new ownership.

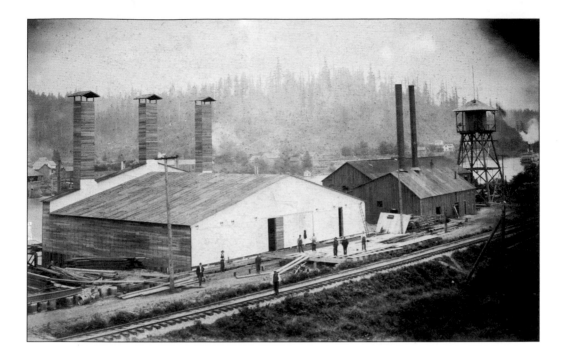

The Duff Shingle Mill, shown in the photograph above, burned down in 1895 and was replaced by the Metcalf Shingle Mill. After the Metcalf Shingle Mill burned in 1904, the Crescent Shingle Mill, shown in the c. 1930s image below, was built in its place at the foot of Academy Street.

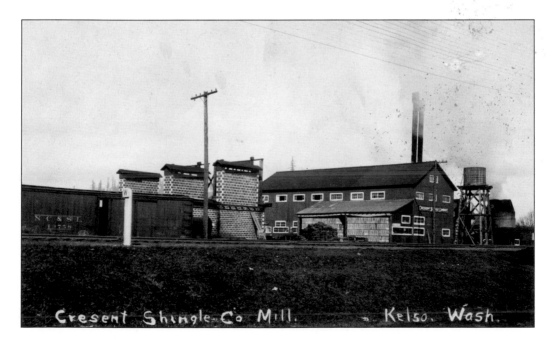

Cresent Shingle Co Mill. Kelso. Wash.

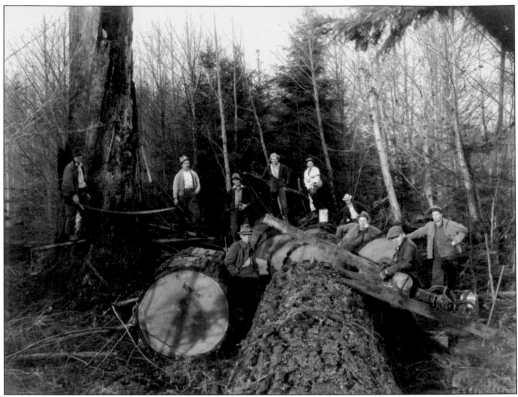

From crosscut saws that were generally operated by two individuals, the cutting of logs improved with crude mechanized saws in the late 1920s. The two unidentified individuals at the left of the photograph are holding a crosscut saw.

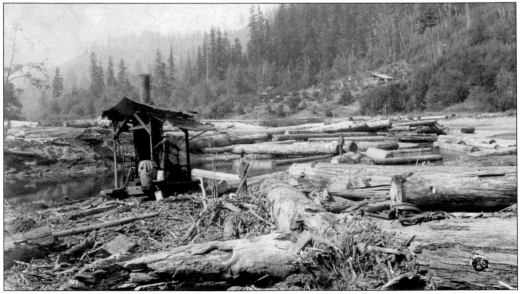

Donkeys, as they were called, were steam-operated machines that used cables to yard logs from one place to another. This one is at the log dump of the Shovelin Logging Camp on the Upper Coweeman River, east of Kelso, around 1910.

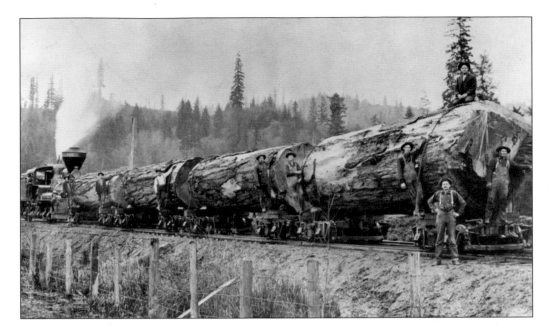

Loggers arriving in the Pacific Northwest encountered much larger timber than they had worked with in the eastern and upper Midwest. This huge Douglas fir tree (above) was felled by the Ostrander Timber and Railway Company and had to be cut into multiple sections to be transported to the mill. The Ostrander Mill and log pond are shown around 1917 (below).

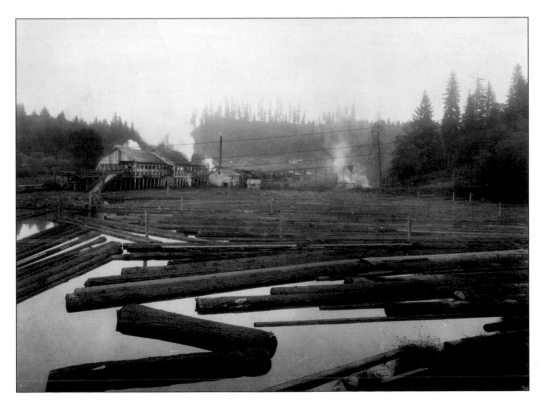

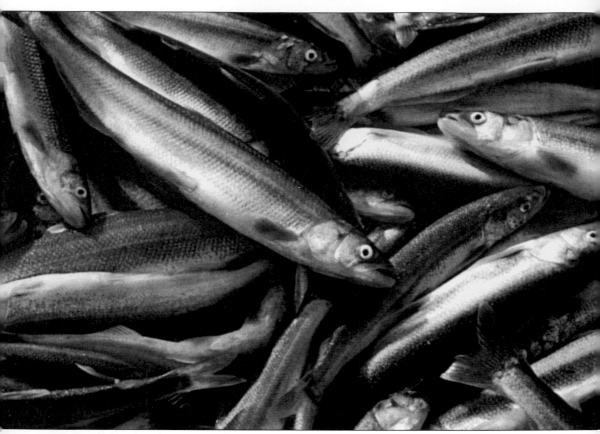

Meriwether Lewis of the Corps of Discovery said of the smelt (eulachon, or candlefish), "I think them superior to any fish I ever tasted." This small, silvery, oily fish used to migrate in large numbers up the Columbia River in January and into the Cowlitz and Lewis Rivers shortly thereafter. Some years, the run of smelt was so large that it would last into early spring. Initially, there was no limit to the amount that could be harvested. Their numbers over the last few years have decreased markedly, however, to the point where catching them has been severely limited.

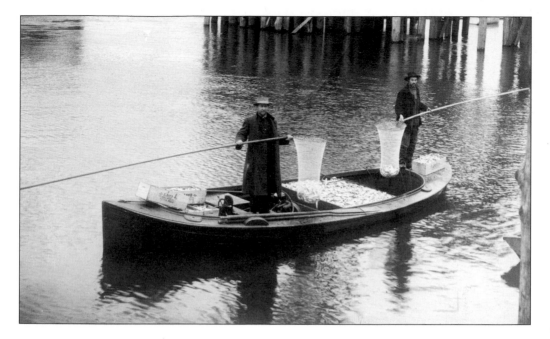

Smelt were easily taken by long-handled dip nets from a boat, and there were often so many in the net that it was difficult to haul it into the boat. The photograph below shows a boatful of smelt that was caught in a forenoon. The load contained approximately three tons of smelt and brought the owner $24.60 in February 1926.

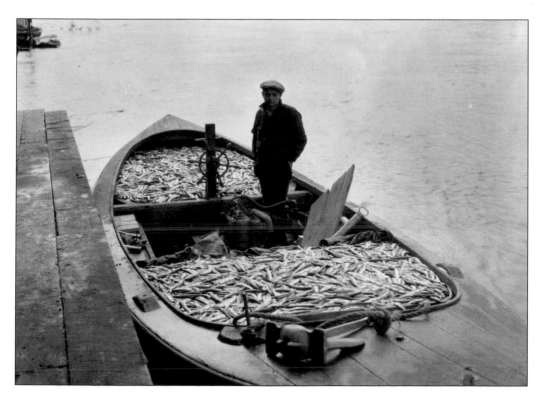

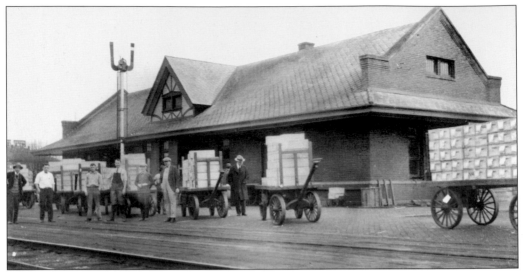

Smelt harvested from the Cowlitz River were shipped via railroad (above) to many places in the United States. Docks were situated on the river directly below the depot, where the fish could quickly be boxed and sent up to the trains. This photograph was taken in 1923 and shows the Henry V. Showers operation at the depot. Showers is the first man on the right.

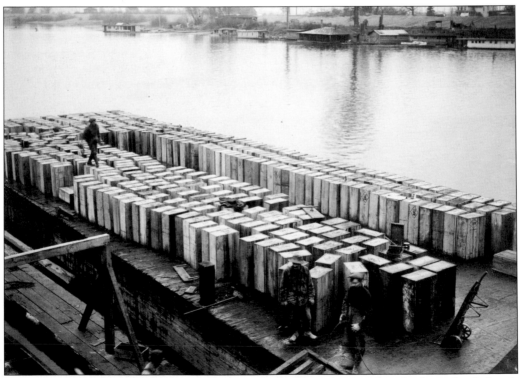

Not only were smelt shipped to many locations in the United States, but this barge loaded with boxes of smelt in February 1926 would be sent to Portland, salted, and shipped to Asia. Notice the many boxes, indicative of just how many smelt there were in earlier years.

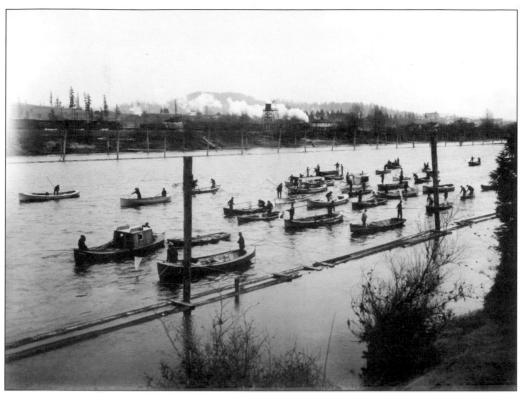

Once the smelt were sighted in the river, usually by flocks of gulls that accompanied their returning journey upstream, people took to their boats and began dipping for the fish. However, if someone did not have a boat, he or she could also be successful by dipping from the bank with a net on the end of a long pole. People would often wade far into the river to try to reach the main body of the migrating mass.

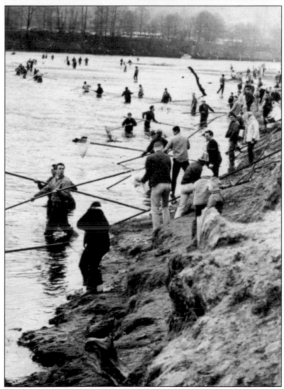

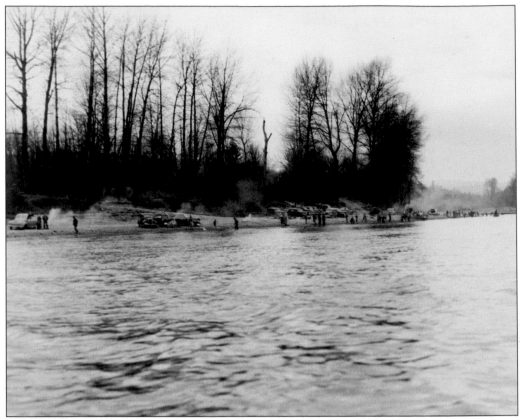

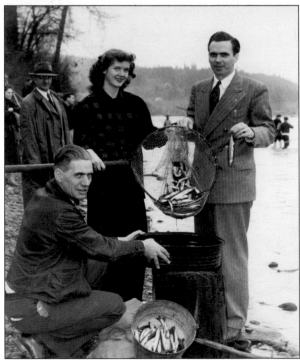

Riverside Park on the west bank of the Cowlitz River in Lexington, where people could drive right down to the bank, was a popular location for dipping smelt. Most people, however, did not usually dip for smelt in a suit and tie. The woman in the photograph at left is believed to be Dorothy (Brannon) Nelson, and the others are unidentified. George Miller, one of the authors, spent many hours dipping for smelt along the river, as he lived just north of Riverside Park. As with many local people, smelt were a part of his diet in the winter, a great source of oil-rich protein during an otherwise lean time of year.

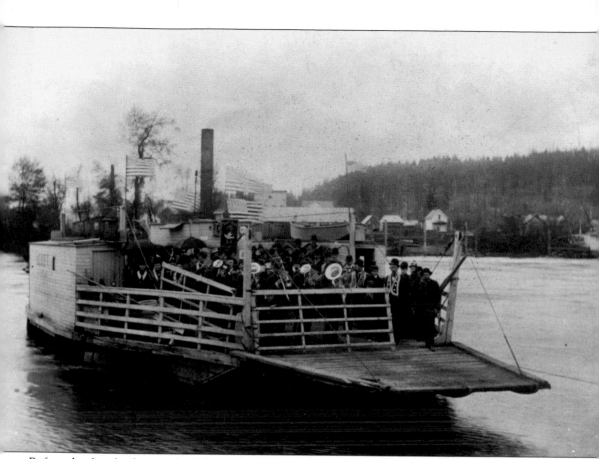

Before the first bridge was built between Catlin and Kelso in 1904, a ferry brought passengers over the Cowlitz between the two towns. Here the ferry *Alkey* (an alternate spelling of the Washington State motto "Alki," meaning "by and by" in the Chinook language) is transporting a Kelso band, members of the Castle Rock Pinetree Lodge No. 29, Daughters of Rebekah, and local Independent Order of Odd Fellows members from a picnic in Catlin to Kelso in the 1890s. The ferry crossing cost 5¢ per person.

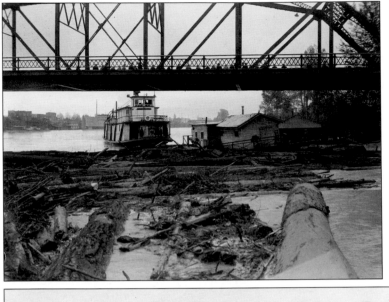

Steamboats and stern-wheelers provided much of the transportation along the Cowlitz River in the late 1800s and early 1900s. They could access the river for many miles, depending on how much water was in the river. This photograph shows the steamship *Wauna* trying to free a logjam beneath the Allen Street Bridge in October 1926.

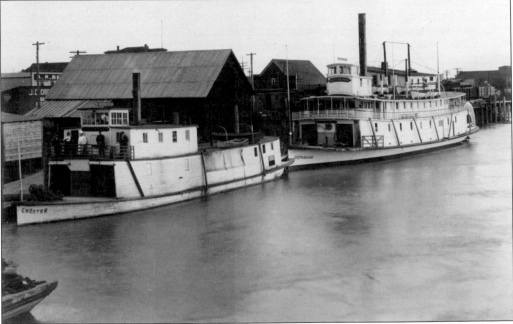

The two vessels shown in this photograph are the *Chester* and the *Joseph Kellogg*, both owned and operated by the Kellogg Transportation Company. The boats are tied up on the east bank of the Cowlitz River, on the Kelso waterfront. The Kelso Railroad Depot, built in 1911, can be seen above the bow of the *Joseph Kellogg*. In the background to the far right is McDonough Hall (later known as Glide Hall, see page 102). To the left, on First Street, are the tops of the A.R. Remick Store and J.D. Organ's coal warehouse. The Kellogg Transportation Company served Cowlitz River communities for over 30 years, from the 1880s into the 1910s. It had the *Chester* built in 1897 specifically for navigation on the Cowlitz River, parts of which get very shallow in the summer. Able to navigate in only a foot of water, the *Chester* ran from Kelso upriver to Toledo, and its planking was constantly being replaced due to the fact that the bottom of the boat was literally sanded down as it slid over the Cowlitz River sandbars.

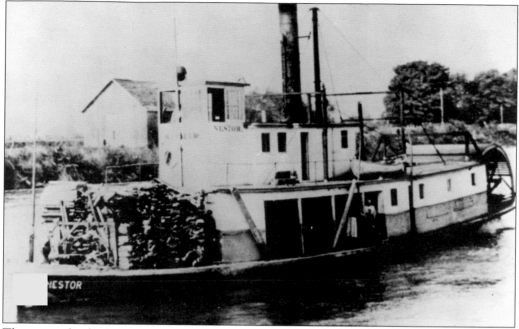

The stern-wheeler *Nestor* was a popular vessel on the Cowlitz River. It is shown here in 1925 near the remnants of the earlier town of Freeport, which was located just south of Kelso on the west bank of the Cowlitz River. A load of lumber appears to be stacked on the foredeck. The *Nestor* was built by Capt. C.P. Stayton's Columbia & Cowlitz River Transportation Company at Catlin in 1902.

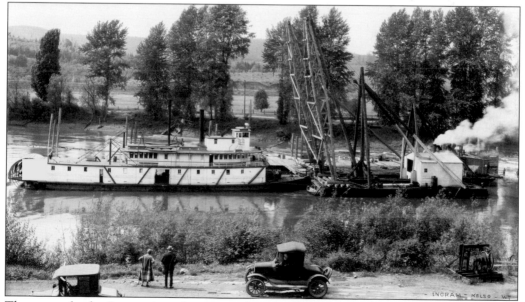

The stern-wheeler *Pomona* is pushing crane barges up the Cowlitz River in 1925 for use in the construction of the Weyerhaeuser railroad bridge across the Cowlitz River between what is now Cowlitz Gardens and Beacon Hill, north of Kelso. The bridge is still in use today. Onlookers watch from the bank near their 1923 Ford Model T Runabout. At the time of the photograph, the *Pomona* was owned by the Cowlitz Towing Company and mastered by Capt. Frank G. Wagner.

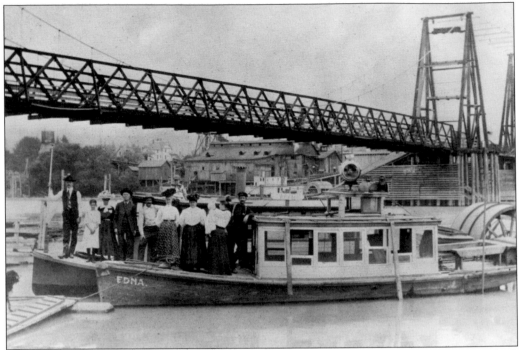

With the second Allen Street Bridge above them, two stern-wheelers are shown tied to the dock on the west bank of the Cowlitz River in 1910. They are the *Edna* (foreground) and the *Wave*. A third, unidentified stern-wheeler is in the background and tied up to the Crescent Shingle Mill. A group of very well-dressed men and women is standing on the deck of the *Edna*. Smaller boats like the *Wave* and *Edna* were used primarily for passenger transport.

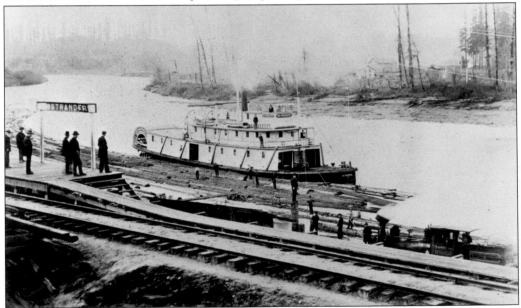

The stern-wheeler *No Wonder* is ready to take a raft of logs down the Cowlitz River from the dock at Ostrander. Men with what are called "log pikes" are standing on the logs. Note the steam locomotive in the lower right of the photograph.

Three

SCHOOLS, CHURCHES, ORGANIZATIONS, AND SERVICES

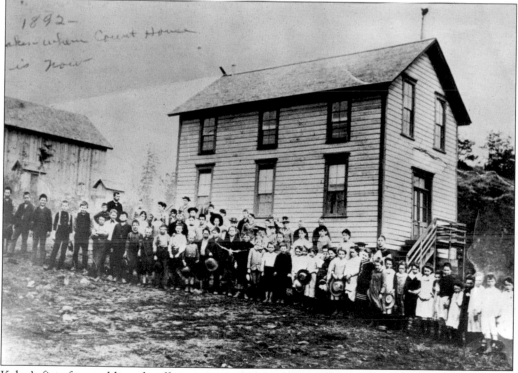

*1892—
taken where Court House is now*

Kelso's first free public schoolhouse was constructed in 1888 on the site where the County Administration Building now stands. It is seen here in 1892. This class is unidentified.

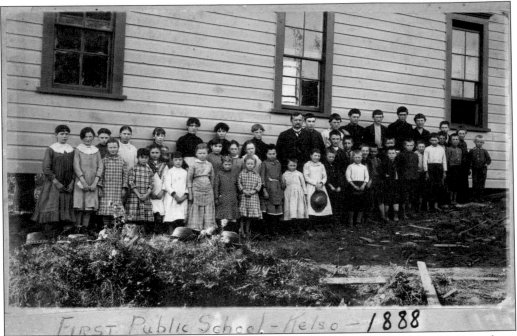

First Public School - Kelso - 1888

Here is the public school's first class in 1888, with grades one through eight. Most of the students in the picture are identified, probably left to right, including Flora Morris, Kate Edlin, Louise Richards, Emma Davolt, Anna Larson, Belle Brooks, Molly Reese, Maggie Edlin, teacher Edwin Pratt, Henry Reese, Frank Edlin, Frank Cornelius, Johnny Edlin, Frank Brooks, Ed Davolt, Frank Morris, Hugh Sawyer, C. Larson, Viola Bolen, Mattie Cross, Susie Richards, Ada Reese, Blanche Pumphrey, Nellie Reese, ? Noaks, Laura Larson, Lettie Bolen, Mary McGowan, Mattie Pace, Nancy Pace, Dolly Malone, Harve Havard, John Dennis, ? Sonneland, Sam ?, Victor Wallace, Ed Pace, Claude Sawyer, ? Cross, Charlie Morris, Enos Noaks, Dave Edlin, Jim Spillman, Bert Lysons, and Hick Malone.

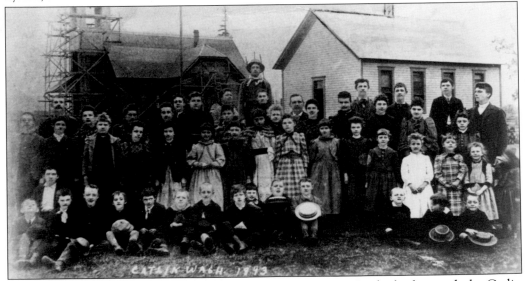

Catlin School students pose outside their schoolhouse in 1893. In the background, the Catlin Methodist Church is under construction.

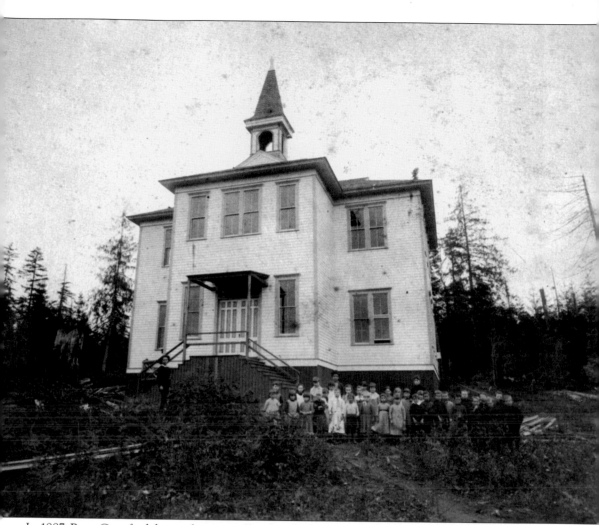

In 1887, Peter Crawford donated a piece of land to the local Presbyterian church for the location of a private Presbyterian school. Once constructed, this two-story, four-room school became known as the Academy, and it lent its name to the street that ran up the hill to the school. Through the church, private high school classes were offered there, the first in the county. The building was torn down in 1921 to make way for the construction of a new high school (see page 67).

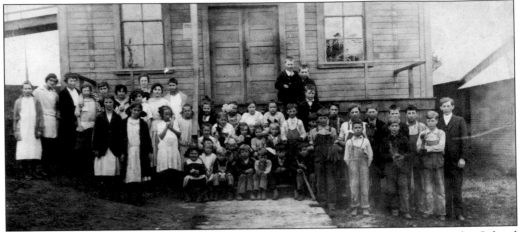

Vern Duncan, Ruth Cook, and Vera Knudsen were the teachers of these Ostrander School students in the 1914–1915 school year. The community of Ostrander maintained its own first-through-eighth-grade school into the 1950s, when it consolidated with the Kelso School District. Thanks to a Works Progress Administration project in the 1930s, the Ostrander School once boasted the best elementary school library in the county.

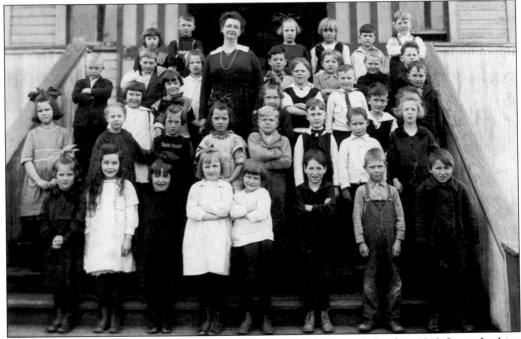

Seen here with one of her classes on the steps of the Washington School in 1919, Lucia Jenkins was a longtime Kelso educator. Beginning her teaching career at the age of 15 in 1884 near her parent's homestead at Martin's Bluff, south of Kalama, she went on to complete her degree at the Normal School in Ellensburg (now Central Washington State University). In 1905, she moved with her family to Kelso and became the primary teacher and principal of the grade school. During the 1910s, Jenkins was twice elected county superintendant of schools, having been endorsed by both the local Democrats and Republicans. After World War I, she returned to her position as principal and teacher at the Washington School. She retired in 1934 at the age of 65, having taught more years than anyone in the history of the county. Jenkins died at the age of 90 in 1960.

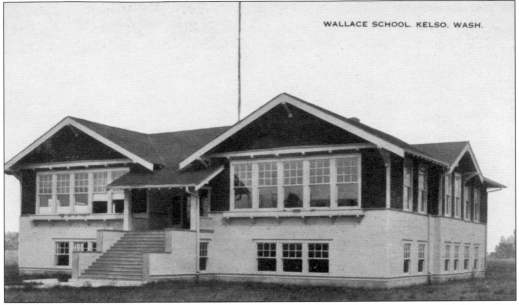

The original Wallace Elementary School, seen here soon after construction, was built in 1912 to educate the children of South Kelso's new Wallace additions. Located on Elm Street between South Fourth and Fifth Avenues, the building has since undergone several major remodels.

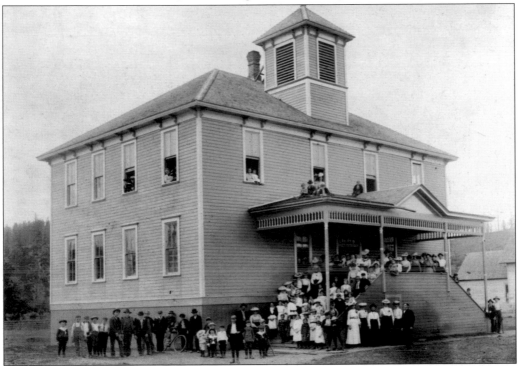

By around 1900, Catlin's school-age population had also grown, requiring the construction of this two-story schoolhouse located on the western outskirts of Catlin. In 1948, the property was sold to the Cowlitz Dairymen's Association, which constructed a creamery on the property. Today, the site houses the Twin City Mall complex on the Kelso-Longview border.

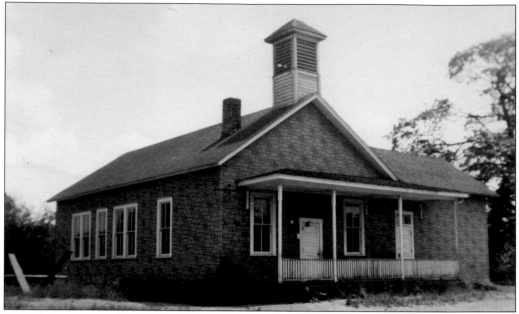

The Lexington area, like Ostrander, used to have its own first-through-eighth-grade school, seen here around the 1930s. George Miller, one of the authors, attended first through the third grades at this school in the mid-1940s. Though the Lexington community has its own identity, it remains unincorporated, and the southern part of the community receives mail through the Longview Post Office, while the northern part is handled through the Kelso Post Office.

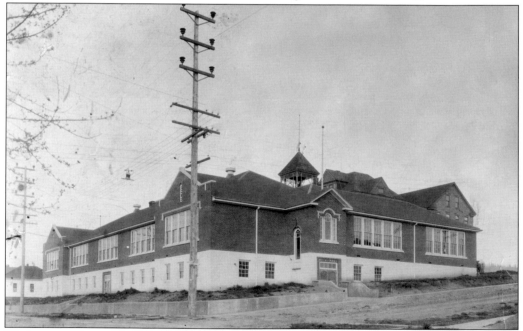

Washington Elementary School, on North Fifth Avenue between Crawford and Columbia Streets, is seen here soon after construction in 1923. The top of the old Washington School can be seen behind the new one. This building served the children of North Kelso until it was torn down in 1980 to make way for construction of a new school administration building.

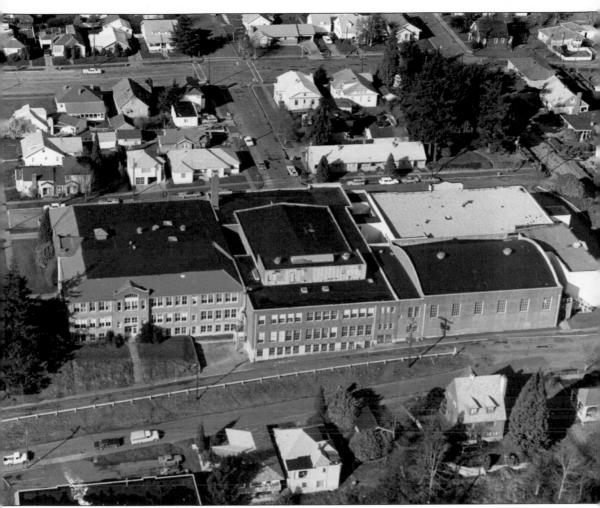

In 1922, a new Kelso High School was constructed on North Seventh Avenue between Church and Academy Streets, on the site of the former Academy. Soon after, a junior high school was constructed behind the high school; it was later named Carl Puckett Junior High School, after a former principal. This aerial view of the junior high/high school complex (Academy Street in the foreground) was taken in the 1960s after junior high classes had been moved to the new Huntington Junior High School. Due to the aging infrastructure of this complex and a rising student population, a new high school was built on Allen Street in 1970. The old buildings were sold and then demolished in the early 1980s, though their footprints can still be seen between North Seventh and North Ninth Avenues.

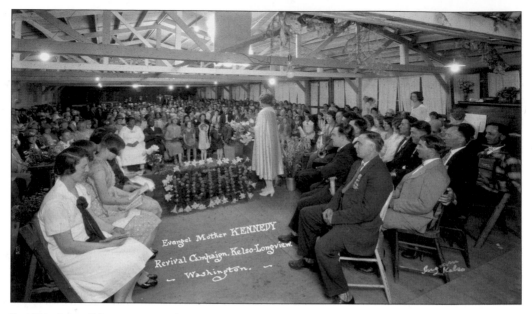

In 1931, the well-known evangelist Minnie "Ma" Kennedy (seen preaching above) hosted a revival at the Longview-Kelso Gospel Hall. Her visit to the area included baptizing the faithful in the Cowlitz River (below). Kennedy and her daughter, Aimee Semple McPherson, had a tempestuous relationship that was the subject of many a tabloid-like news article.

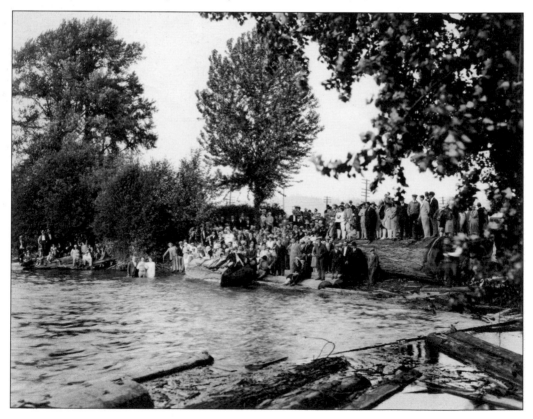

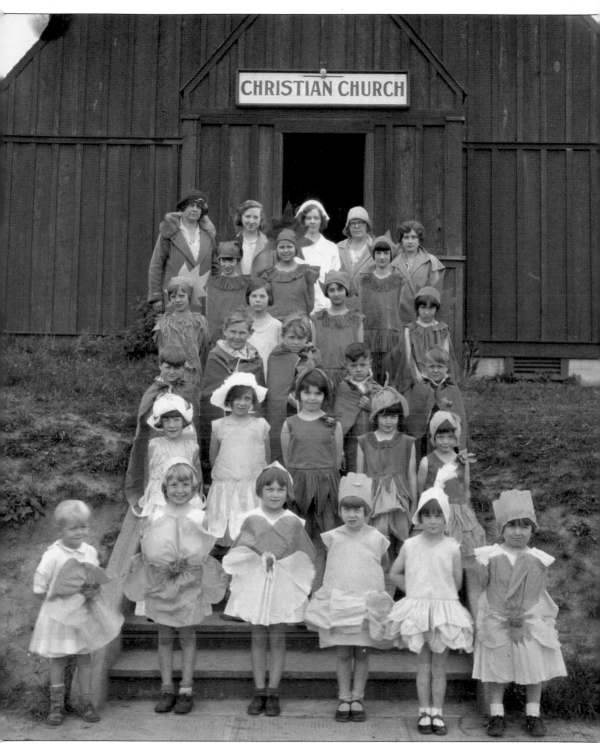

Easter was an occasion for the children of Kelso's Christian Church to dress in their most colorful outfits, as seen in this 1931 photograph. The Christian Church was on the corner of North Fourth Avenue and Crawford Street.

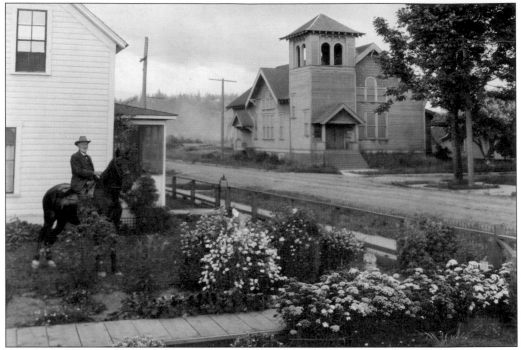

Rev. Dan Delano, seen here on his horse in 1918, was an early-day "saddlebag missionary" to Cowlitz County's loggers. In the background is the Kelso First Baptist Church organized in 1906 and built at South Fourth Avenue and Oak Street in 1911. A major remodel of the church in the early 1960s left Kelso with one of its more architecturally distinct buildings.

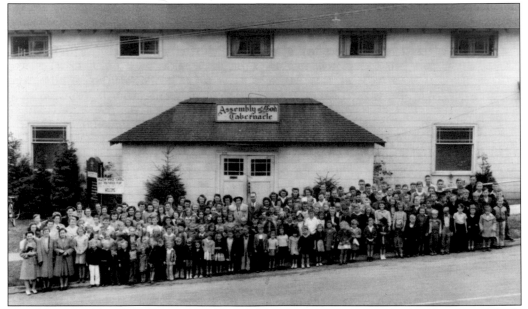

A Kelso Assembly of God summer Bible school group is posing outside the church on North Fifth Avenue in the 1940s. Built in the late 1930s under the leadership of pastor Ted Silva as the first permanent home of the Kelso Assembly of God Church, this building was replaced by the current church in 1966.

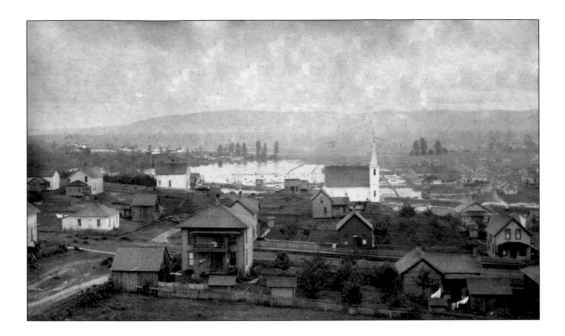

The Kelso Presbyterians built the first church in the new city of Kelso in 1888 (seen above during the 1894 flood). The original church was located at Church Street and North Seventh Avenue. In 1908, a new church was built at the northwest corner of North Third Avenue and Academy Street (below, taken in the 1930s). In 1959, the second building was replaced by a more modern edifice at the same location.

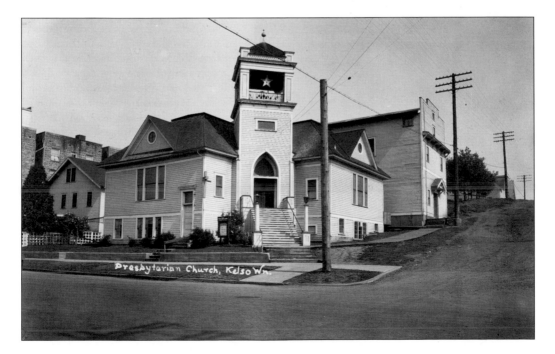

Kelso's Gloria Dei Lutheran Church had its start in 1947 when the church bought and renovated this residence on Crawford Street and North Fourth Avenue. In 1953, the congregation began constructing a new church, the current building that sits on North Fourth Avenue between Crawford and Columbia Streets.

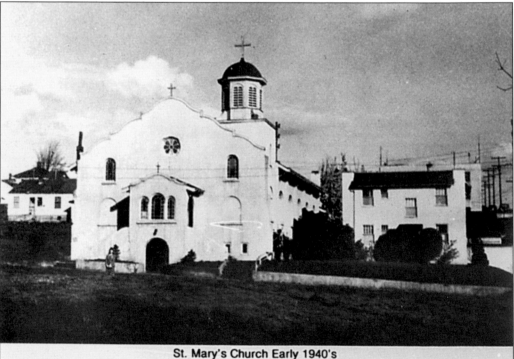

St. Mary's Church Early 1940's

St. Mary's Catholic Church (seen here in the 1940s) on North Fourth Avenue between Church Street and Cowlitz Way was constructed in 1925 for the area's growing Catholic population. Prior to that time, services had been held in the old Catlin Methodist Church. The new church's Mission Revival architecture is rare for this area. In the late 1970s, a new St. Mary's Catholic Church was built on Allen Street near the Coweeman River. This old church was then sold, in 1979, to the Kelso Assembly of God to house a youth and recreation center, for which it is still used today.

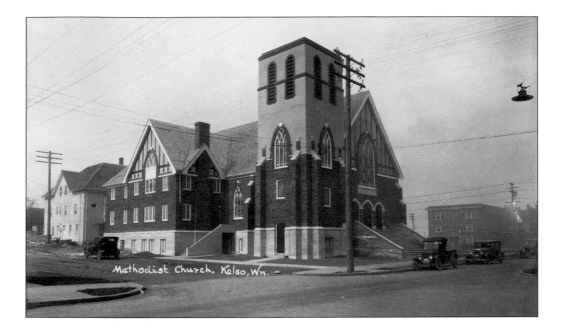

This Kelso Methodist Church (above) was built in 1929 to replace the 1889 building at 205 Church Street. The new church was behind the old (seen here in the background to the left) and faced Cowlitz Way. The old church was then converted into apartments, one of which was reserved for the minister and his family. On March 27, 1932, the Methodist youth performed an Easter Pageant in the new church (below). This structure was destroyed by fire in 1938 (see page 123).

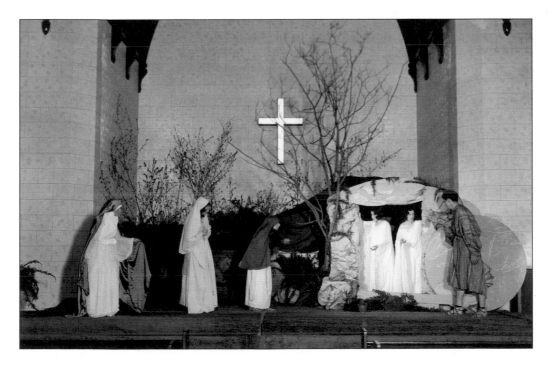

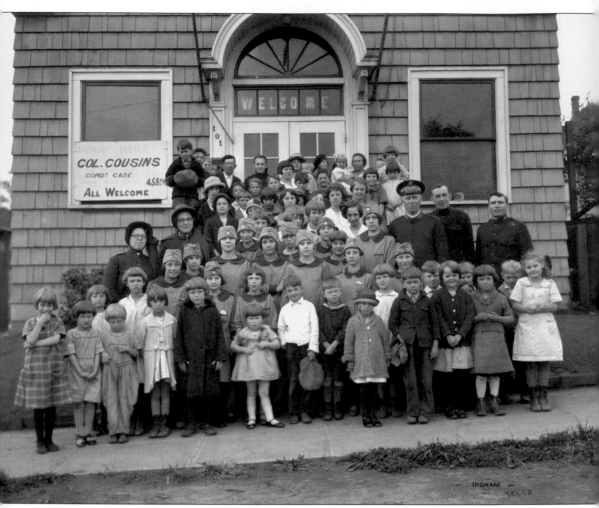

In 1922, Salvation Army captain Bernice Wellman came to Kelso to establish a branch of the well-known religious and charitable organization. With help from city clubs and townspeople, money was raised for the purchase of a city lot and the construction of a new home at 101 Church Street in 1923. This photograph, taken about 1928 or 1929, shows a group of children and Salvation Army staff on the steps of the new building with Colonel Cousins in the Salvation Army hat. Charitable drives conducted by the Salvation Army collected food and clothing for the less fortunate in the community, which was especially important during the Depression years. The Kelso Salvation Army remained in that building until moving to a new location in West Kelso in 1971.

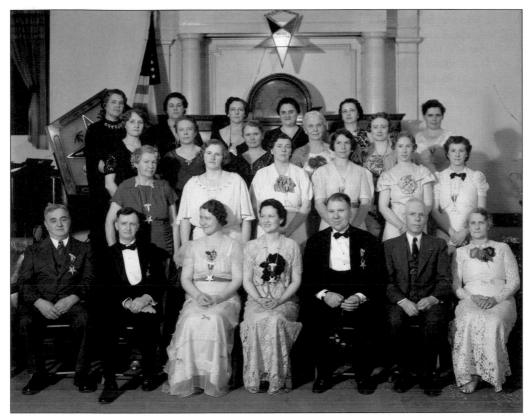

Kelso Masonic Lodge members are dressed in their finest for this group portrait taken in the upstairs meeting hall of the Masonic building at 204 South Pacific Avenue in 1939. The Kelso Masonic Lodge was granted a charter in 1893 but met in various places in Catlin for its first 10 years. The Masonic Building in Kelso has been the lodge's home since it was built in 1924.

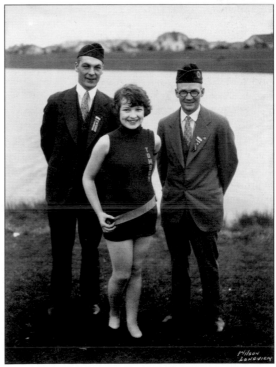

George Bee (left) and R.E. Ball of Kelso's Guy Rathbun American Legion Post are standing with Lucille Oatman, Miss Kelso 1926, at Lake Sacajawea in Longview. The Guy Rathbun Post, named after a popular Kelso serviceman killed in World War I, was founded in 1919. In addition to being a veteran's organization, the post also helped with various community service projects and youth activities, like sponsoring Lucille Oatman for the Miss Washington Pageant in 1926.

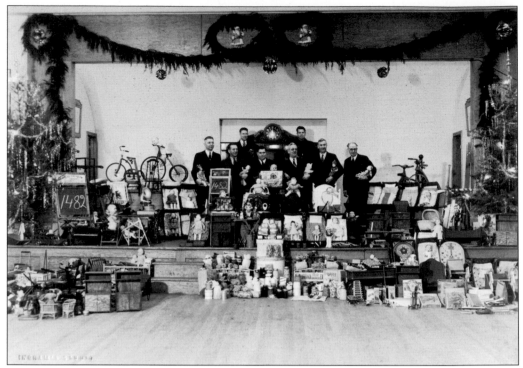

The Kelso Elks Lodge No. 1482 was officially founded in 1924. The first exalted ruler was Fred Graham. Lodge members are seen here in the 1930s with toys collected for their Christmas charity toy drive. They are, from left to right, Walter Trantow, L.S. Moen, W.C. Nicklaus, Louis E. Brown, Dr. R.H. DeLap, Rudy Rydberg, George Secord, and Bert Decker. In 1945, the club bought out the Coweeman Golf Club, where the Three Rivers Mall is now, and a new lodge was built for them in 1958 on the edge of the course at 900 Ash Street. The golf course was sold for the future mall in 1980, and the club purchased land for a new one (Three Rivers Golf Course) off South River Road.

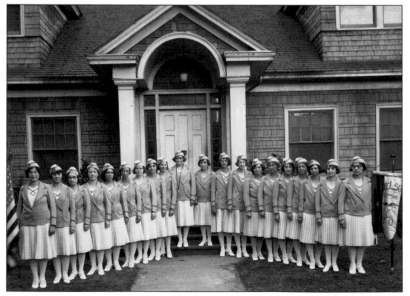

The Lady Eagles Drill Team is lined up for a picture outside the Kelso Club in 1931. That year, Kelso's Fraternal Order of Eagles Men's Drill Team won the state competition at the convention in Hoquiam.

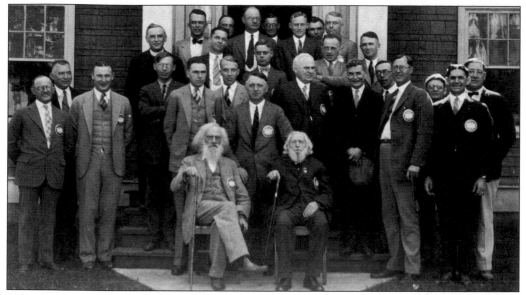

Kelso Rotary Club members are standing outside the Kelso Club on Oak Street in 1925, two years after the Kelso Rotary was founded. The occasion for the photograph was a visit from Washington State pioneer Ezra Meeker (seated to the left) on one of his last trips retracing the route of the Oregon Trail from St. Louis up to Puget Sound. Having come west on the original trail, Meeker settled for a short time in the Kalama area before moving north to settle near Puyallup. Toward the end of his life, he made several trips back over the trail in an ox-drawn wagon to bring public awareness to the efforts of the pioneers, and he left monuments to them in many locations. These monuments came to be called "Meeker Markers." Seated to the right is J.G. Jones, one of Kelso's first mayors and a former Kelso store owner.

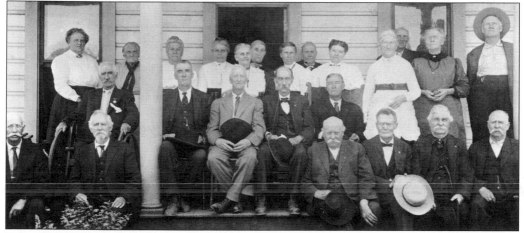

Kelso Grand Army of the Republic and Auxiliary members pose for a portrait on the porch of Henry Allen's home around 1900. The Grand Army of the Republic, or GAR, was a club for Union Civil War veterans. In this photograph, from left to right, are (first row) unidentified, Peter Knapp, Oliver Byerly, G.W. Taylor, Jacob Stoves, and unidentified; (second row) Henry Allen, Henry Cronk, Walter Lysons, Charles Hall, and Scott Thompson; (third row) Glena (Mrs. Walter) Lysons, Sarah (Mrs. Henry) Allen, Mary (Mrs. Henry) Cronk, Mrs. Peter Knapp, Mrs. Roswell, two unidentified members, Patience (Mrs. Abner) Glover, Mrs. Scott Thompson, Mrs. Scott, Mr. Scott, Sarah (Mrs. Jacob) Stoves, and Frank Chattermole.

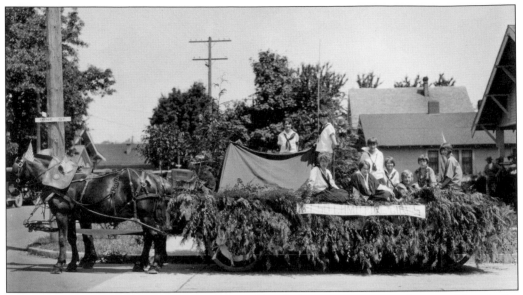

Many young area girls participated in the Camp Fire Girls organization over the years. Mary Laffey Collins had the distinction of founding the second group of Camp Fire Girls in the nation at Ostrander in 1910. Kelso's first group was organized in 1917 by Hattie Barlow Olson. Here, a group of Camp Fire Girls is participating in a Fourth of July Parade in the late 1920s on Pine Street in Kelso. Seven of the nine girls are identified, in no particular order, as Marjorie Williams, Lessne Robinson, Sarah Roberts, Reba Newgard, Catherine Swetman, Beulah Pope, and Etta Wolf.

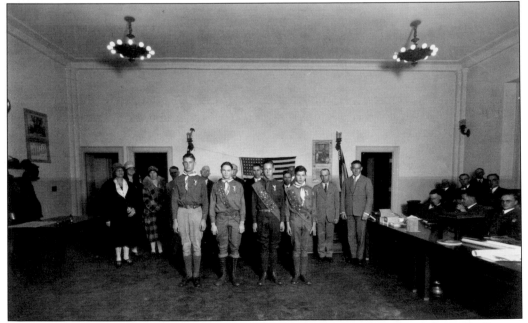

Four Boy Scouts attend their Court of Honor at the Cowlitz County Courthouse (now the County Administration Building) in Kelso in 1926. Kelso's first Boy Scout troop was organized in 1912 by Rev. C.B. Latimer of the First Presbyterian Church. Up into the early 1920s, Kelso had the only troop between Portland and Olympia. For many years before the 1980 eruption, Portland and Kelso area Scouts attended summer camp at Spirit Lake, in the shadow of Mount St. Helens.

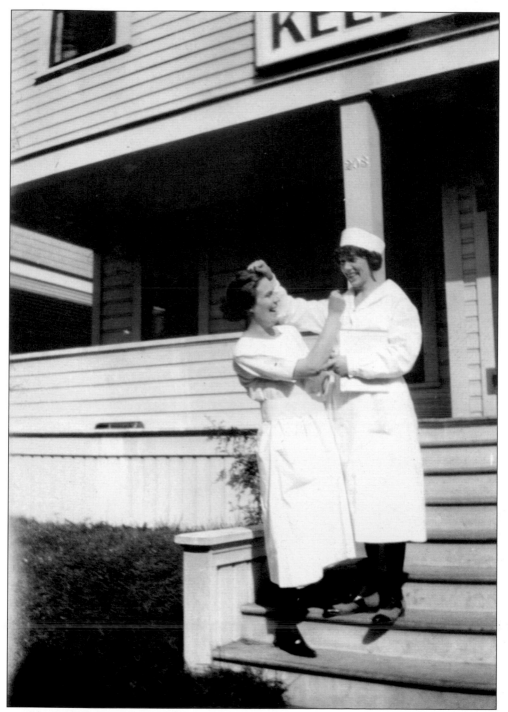

Nurse Elizabeth Parson Smith (right) is joking around with another nurse on the steps of the Kelso General Hospital around 1920. Kelso's Hospital, at 208 Academy Street, was a house converted to a hospital in the 1910s. The main physicians there were Drs. Arthur Davis, Frank Davis, and Earl Hackett. The hospital closed in December 1934, with the patients going to the more modern facilities in Longview.

Kelso's early fire departments were all-volunteer. This group photograph was taken outside one of Kelso's shingle mills in 1896. From left to right are Harry Duff, Dave Edlin, Andrew Hargrave, Roy Clark, J.P. Buford, ? Shaw, W.W. (Dick) Stoves, unidentified, J.A. Springer, Ed Davolt, Ed Arquett, G.F. Gray, W.S. Stoves, J.S. Robb, J.J. Stoves, J.B. Hill, George Potter, Newt Strain, Fred Horbach, L.B. Thornton, and E.J. Masters.

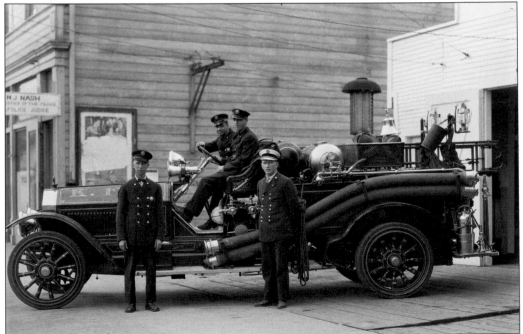

Around 1926, the City of Kelso purchased a new fire engine and was able to pay its firefighters. In this photograph, from left to right, are Otto Disque, Bert Osborn, A.L. "Chet" Crump, and Chief George F. Miller. Chet Crump would become Kelso's fire chief after the retirement of Chief Miller in 1931.

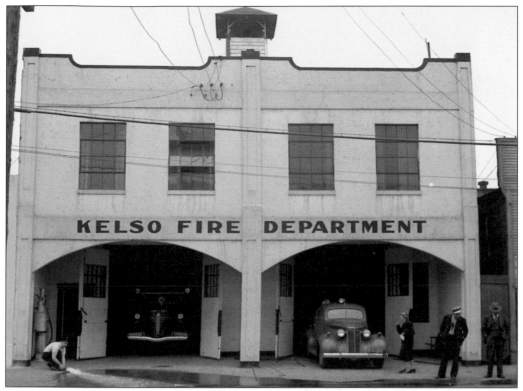

For many years, the Kelso Fire Department had its home at 310 Allen Street (as seen above in the 1940s). The 1970 Kelso Fire Department poses outside that building (below). Members, from left to right, are (first row) Harold Lancaster, Ed Geiger, Cloyd Schneider, Jack Weight, Gary Mansur, and Alan Darr; (second row) Capt. Bertie Wishard, Capt. Iman Wintz, Chief Bill Jackson, Assistant Chief Bill Crimmel, Ralph Abbott, and Bob Huffman; (third row) Larry Halladay, Sid Cole, and Bud Green. In the mid-1980s, the department moved to a larger facility with room for training exercises, at 701 Vine Street, and became a district of Cowlitz County's Fire and Rescue system.

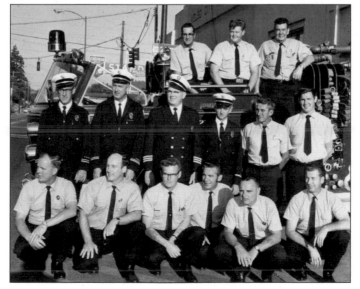

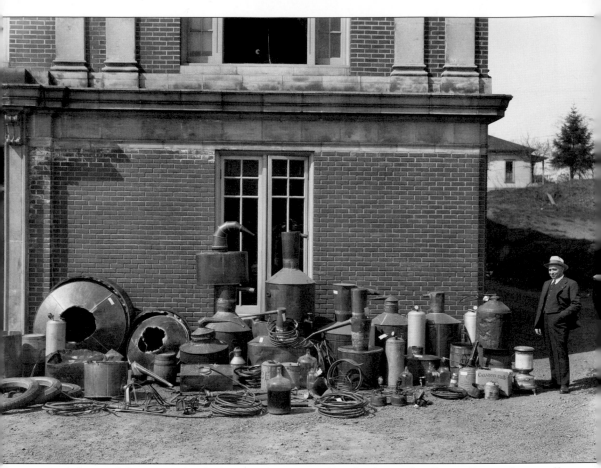

Prohibition did not completely dampen the spirits of local at-home distilleries. Demand was still high, especially among the loggers looking to unwind on the weekends. Local law enforcement officials cracked down where they could. Here, Cowlitz County sheriff C.B. Dill poses with confiscated stills and brewing equipment outside the courthouse in Kelso on March 31, 1930.

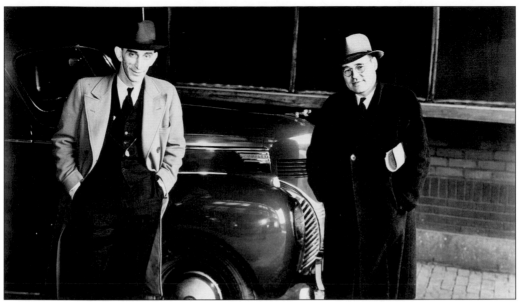

Kelso's law-and-order duo for much of the 1930s and 1940s, police chief Carl Pritchard (left) and Cowlitz County prosecuting attorney Shirley Marsh pose for this photograph on April 7, 1939. Pritchard, a noted Timber League baseball pitcher known as "The Lone Gray Wolf," worked as a Kelso police officer in the off-season throughout the 1920s. He was made Kelso police chief for the first time in 1934 and would go on to serve two terms as Cowlitz County sheriff and another term as Kelso police chief. Pritchard retired in 1964 and died in 1980. Shirley Marsh, a local Kelso boy born here in 1906, served two terms as the county's prosecuting attorney, was a Kelso city councilman, and served as a state senator from 1941 to 1943 and as a state representative from 1959 to 1960.

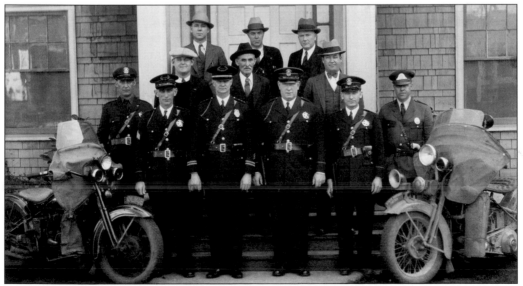

On April 20, 1931, Kelso police officers posed for this photograph, which was later published in the *Northwest Police Journal*, with their patrol motorcycles outside the Kelso Club. Uniformed men in front are, from left to right, O.A. Millard, Carl Pritchard, Chief F.A. Graham, J.L. Wall, George A. Eaton, and George Medlock.

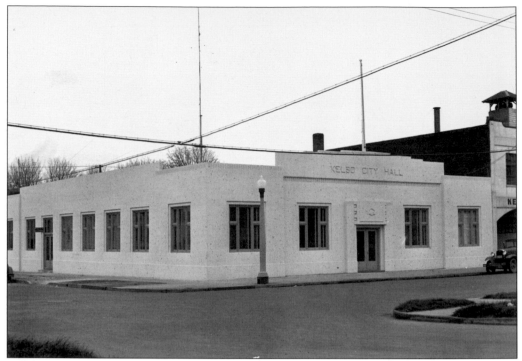

In 1939, the Embassy Theatre on Allen Street was torn down to make way for a new Kelso City Hall, seen here in the early 1940s.

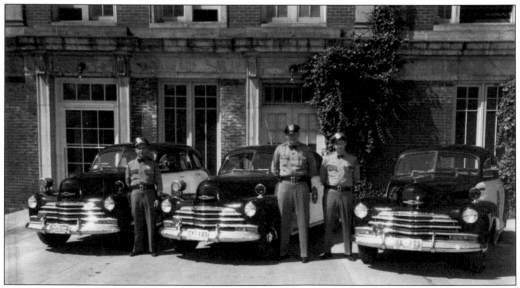

Since the state highways first came through town in the late 1910s, Kelso has been home to a Washington State Patrol office. Seen here on the west side of the courthouse in 1947, local state patrolmen pose with their cruisers. The patrolman in the center is A.B. Little, who served this area for many years.

Four

RECREATION
AND FESTIVITIES

A summer form of recreation was logrolling. Two individuals would stand on a log floating in the water and slowly begin turning it with their feet. The object was to remain on the log and get the other person to fall into the water. Loggers and other individuals would use their caulked boots to obtain a stronger foothold on the log. The loggers would use this event as an exhibition of the skill and balance needed to work on floating logs in the area's many waterways. The event shown here, in the shadow of the second Allen Street Bridge around 1920, drew many spectators.

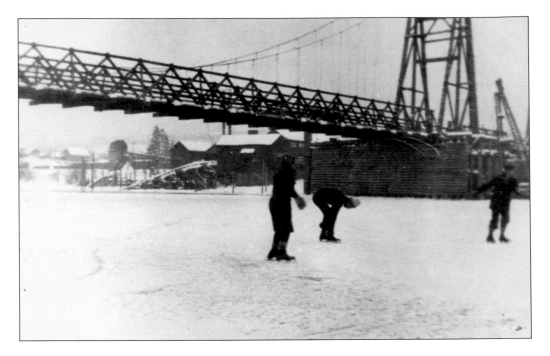

Washington is not without cold, snowy winters—although they are not as frequent as in many sections of the country. Yet, the Cowlitz River has frozen over several times with ice thick enough for some brave ice-skaters to use the river as a rink. The above photograph was taken in mid-December 1922 when the temperature remained below freezing for seven days after a light snowfall on December 12. The photograph below was taken in mid-December 1919. On December 9 and 10, some 20 inches of snow fell in the area. Minimum temperatures, as reported by *The Kelsonian* on December 13, 1919, fell to near and below zero. It remained below freezing for six days.

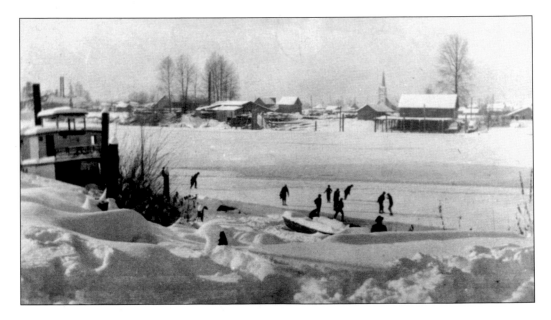

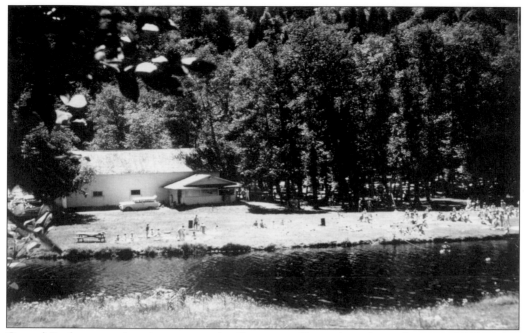

Crystal Pool was a swimming area on the Coweeman River about five miles east of Kelso near the end of Allen Street. Here, the river flowed very slowly on its journey to the Cowlitz River and created an excellent swimming hole. It was a popular gathering spot in the summer for families to enjoy a picnic and swimming in the relatively warm water. A dance hall was also located there.

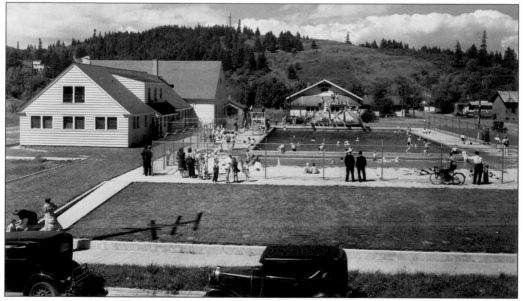

Catlin Pool in West Kelso was built in the late 1930s as a Works Progress Administration project. The pool was named for Mary Catlin, who had deeded the land to the city for recreational purposes only. It was crowded from its opening day in June throughout the summer months, attracting swimmers from all over the area. This photograph shows the pool on its opening day of the season, June 12, 1939. In the last decade, the rising cost of insurance and facilities maintenance forced the city to convert the pool into a water park.

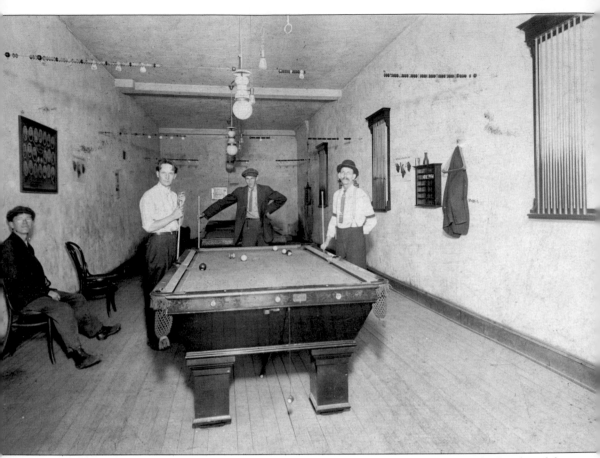

Pool halls are a source of recreation in any town. This pool hall, one of many on both sides of the river, was located in West Kelso in the early 1900s. Three individuals are shown playing pool as another watches. The gentlemen are unidentified.

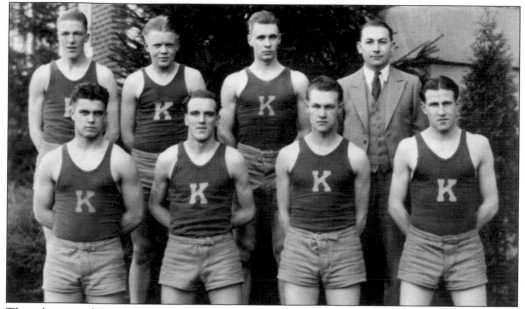

This photograph is of the Kelso High School basketball team in 1931. The players that year included Pete Howe, Rolly Rathron, Ed Dixon, Corky Eyer, Swede Sikstrom, Zip Pietila, and Ken Kinder, with coach Leslie Hoar. The team had set its goal of the state tournament in Seattle early and finished the regular season with 11 wins and three losses. In its first tournament game, Kelso defeated Pullman 30 to 20 but then narrowly lost consecutive games to Raymond, 20 to 25, and Enumclaw, 22 to 27.

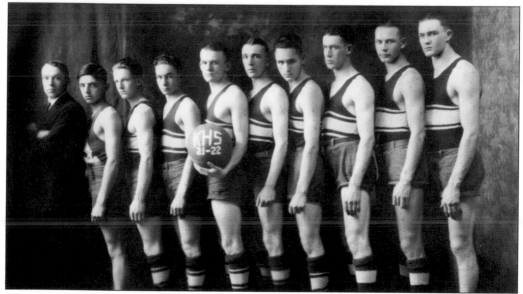

This photograph shows the 1921–1922 Kelso High School basketball team. The individuals are not identified left to right, but players that year from the *Tamahnawus* (as Kelso's yearbook used to be called) include "Freddie" Johnson (captain), "Bill" Deemer (athletic manager), Alfred Taylor, Telle Ayers, Harold Letsinger, "Spot" Deemer, "Chuck" Beiger, "Buster" Snyder, "Ed" Johnson, and "Mitch" Doumit. That year the team won six games and lost four. Opponents included Castle Rock, Silver Lake, Kalama, Woodland, Methodist S.S., and the alumni.

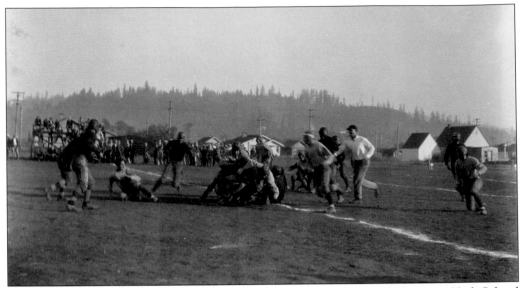

This photograph shows the Kelso High School football team in a game with Union High School from the Vancouver area on October 29, 1926, at the old Schroeder Field. The game ended in a zero to zero tie. Businesses and houses now occupy this location on the south side of Allen Street.

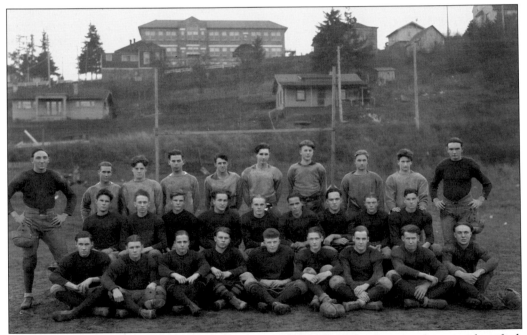

This photograph is of the 1925 football team. The individuals in the photograph are unidentified. However, according to the *Tamahnawus*, the players that year included Arvy Lotham (captain), Oren Eubanks (captain-elect), Wallace Blair, Earl Taylor, Dillard Storie, Charles Baker, Raymond Critchfield, Pete Miller, Frank Odell, John Dickson, Ed Payne, Everett Johnson, Chet Eubanks, William Armitage, Clyde Dale, Hilbert Davolt, Harold McCorkle, and Earl Brawley. The team's record that year was three wins and five losses, but it skunked archrival Longview 20 to zero on "Turkey Day." Frank "Truck" Davis was the coach, and Harold Letsinger was business manager.

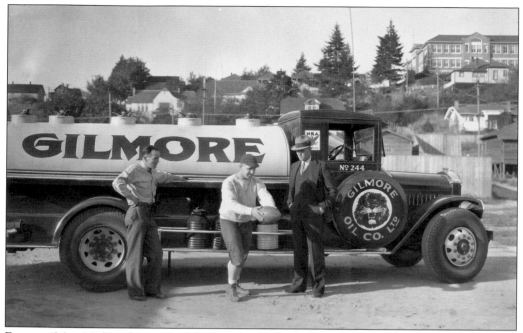

Emmett "Mutt" Schroeder coached the Highlander football team at Kelso High School for 18 years from 1934 to 1953. He compiled a 50-34-14 record in league play, with conference titles in 1939, 1944, and 1946. In 1952, the Kelso School District named its athletic field Schroeder Field in his honor. He is shown about to punt a football in front of a Gilmore Oil truck in this photograph. The other two individuals are unidentified. The old Kelso High School is visible on the hill in the upper right of the photograph.

This photograph shows the Kelso Highlanders football team in action against the R.A. Long Lumberjacks of Longview on Friday, October 28, 1983, at Schroeder Field. Kelso won the game 48 to 3. The Highlanders defeated Camas the next week to win the St. Helens Conference title and then went on to defeat Sedro-Wolley 28 to 7 for the Washington State AA Football Championship. Beginning in 1923, the traditional Kelso-Longview football game was always held on Thanksgiving Day. The final "Turkey Day" game was in 1972.

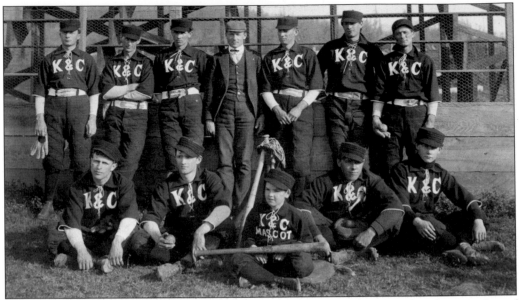

The Kelso area supported semiprofessional baseball teams in earlier years. This photograph is of the Kelso-Catlin team in the 1890s. Those shown are, from left to right, (first row) Eddie Kindorf, Harry Duff, Fred Cole's boy, Pal Johnson, and Ernie Catlin; (second row) F.A. Bird, Teed Gray, Frank Catlin, manager Charley Abbott, Grant Watson, Bill Nelson, and George Smith.

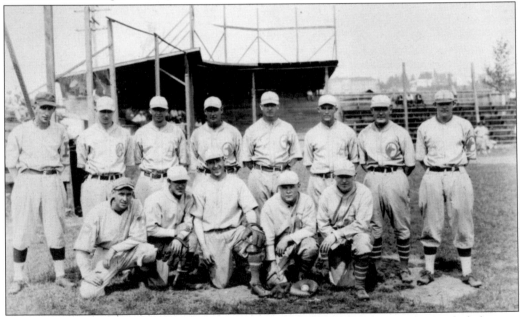

The Kelso Timber Wolves were part of a semiprofessional baseball league that included teams from western Washington cities. The league was in existence for many years but probably most active in the 1920s into the 1940s. As salaries increased, however, several towns found they could not support a team. Salaries were rarely reported, but the June 2002 *Cowlitz County Historical Quarterly* indicates they may have ranged from $200 to $500 a month in 1926. By 1950, the league had disbanded. This photograph shows a team from the 1920s at the Kelso ballpark. The players are unidentified.

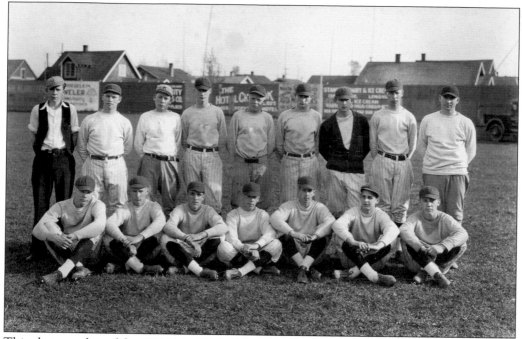

This photograph is of the 1929 Kelso High School baseball team. The players include, from left to right, (first row) Chuck Klawitter, Leslie Darr, Rolly Rathron, "Doc" Thompson, Mervin Haskins, Ray Schwartz, and Dale ("Sandy") Combs; (second row) Max Dalton, Ray Critchfield, Lauren Sherman, Glen Swetman, Zip Pietela, Gayle Axtell, Don McFadden, Ray Jewett and Coach Mitchell. In league play, the team won eight games and lost two, putting them in second place.

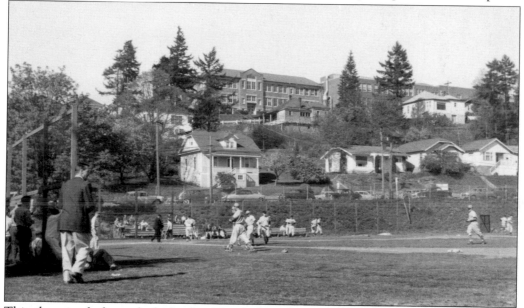

This photograph shows the high school baseball team in action at Schroeder Field in the 1950s. The high and junior high schools are clearly visible in the back of the photograph on the hill. The person standing is Otto Koefler, who was author George Miller's English teacher when he attended high school between 1953 and 1955.

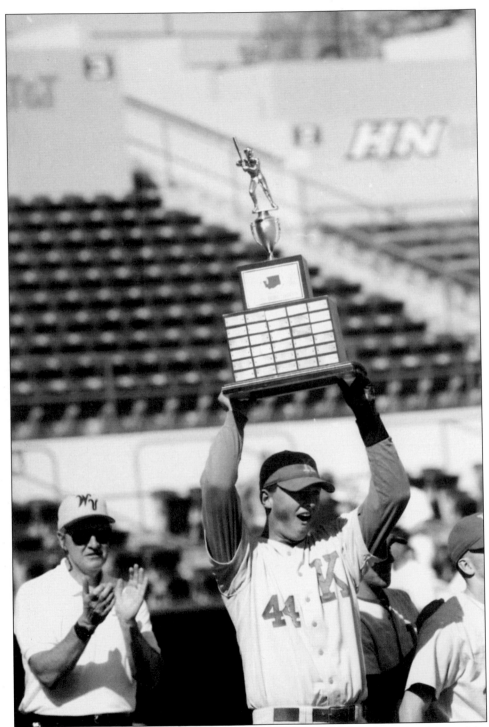

In 1995, the Kelso High baseball team went on to win the state AAA championship on May 27. Its final record was 21 wins and 6 losses. Senior Marty Sewell (one of the team's standout pitchers and hitters) holds the state trophy after the team defeated Wenatchee 8 to 4 at the final game of the state tournament in Spokane.

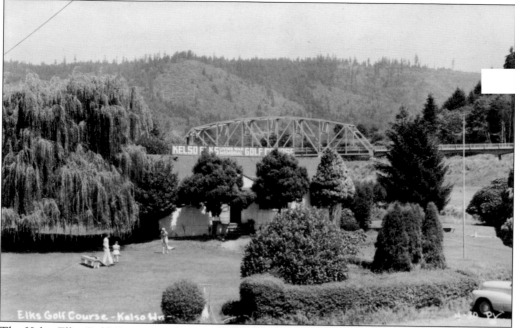

Elks Golf Course - Kelso Wn -

The Kelso Elks Golf Course on the east side of the city was a popular recreation site. The Kelso Elks purchased the privately owned Coweeman Golf Course in 1945 and operated it on that site until 1980. It was covered with sediment dredged from the Cowlitz River after the eruption of Mount St. Helens. The Three Rivers Mall is now located at the site.

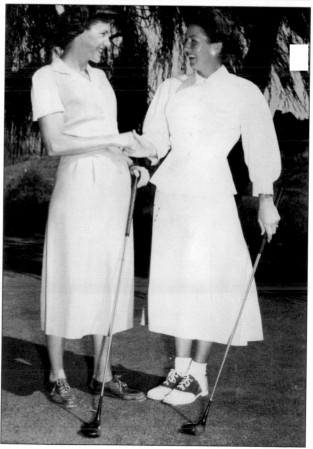

During its existence, the Kelso Elks Golf Course hosted many tournaments. This photograph is of the 1947 Kelso Lady Elks Golf Association Championship. Shown in the photograph with their drivers are Bea Kimball (left) and Lorene Pollard.

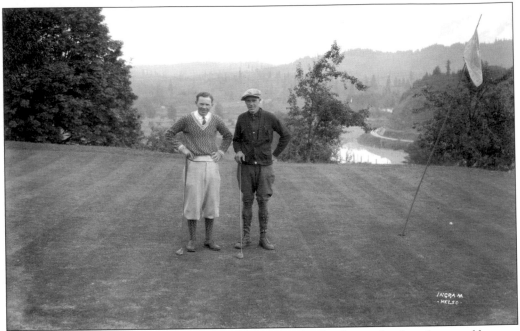

Little known to the authors until research began on this book was the fact that a golf course existed on Beacon Hill on the west side of the Cowlitz River just north of West Kelso. It was known by various names, including the Cowlitz Valley Country Club and Cowlitz County Golf Association's Club. The golf course had nine holes and was in existence from 1926 into the 1930s. The two golfers in the above photograph are unidentified, and those just outside the clubhouse in the photograph below are also unidentified. Dues were $175 a year.

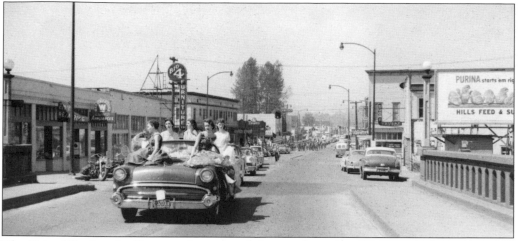

The Kelso Elks Loyalty Day parade attracted thousands to the city. It would feature notable individuals or groups and sometimes football, basketball, or baseball teams. In this photograph taken May 1, 1957, Libby Aldrich, Miss Washington for that year, and her court are shown. Miss Washington is the individual in the middle. The ladies in her court are unidentified. The photograph was taken from the Allen Street Bridge while looking west on Main Street.

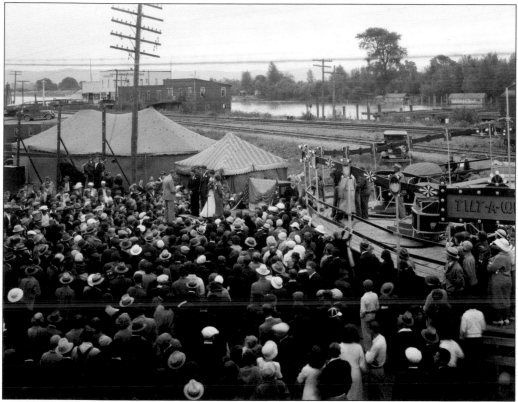

Amusement companies would often bring their traveling carnivals through the city, stay for a few days, and then move on. This one, run by the Browning Brothers Amusement Co., was set up in proximity to the railroad tracks along South First Avenue. In this photograph, a large crowd has gathered for an outside wedding near the amusement park.

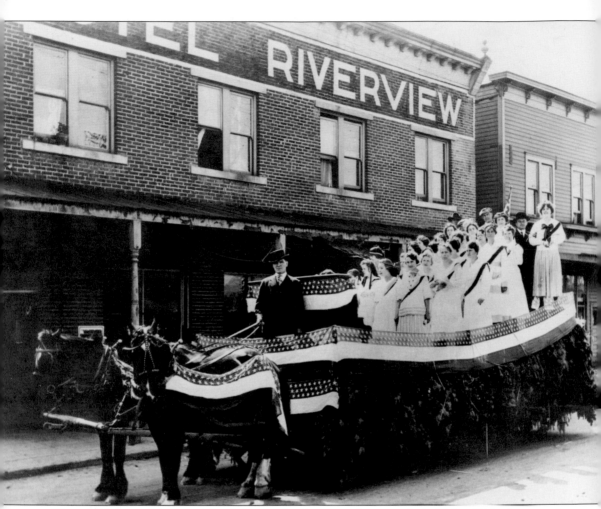

The celebration of America's birthday used to be cause for a parade in Kelso. This photograph shows the Methodist church Fourth of July parade float for the 1919 parade. It was taken in front of the Hotel Riverview on Allen Street. The individuals on the float are unidentified.

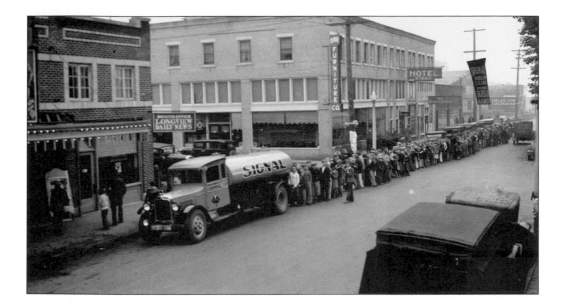

When the movie *Tarzan the Fearless* came to town in 1933, it drew hundreds of youngsters. The photograph above shows a Signal Oil truck followed by a crowd for at least two blocks to the Liberty Theatre. Several businesses are shown in the photograph below, including the Liberty Barber Shop, Longview Daily News branch office, Orr Furniture Company, Hotel Strand, the Kelsonian Tribune, and Kelso Junk & Salvage.

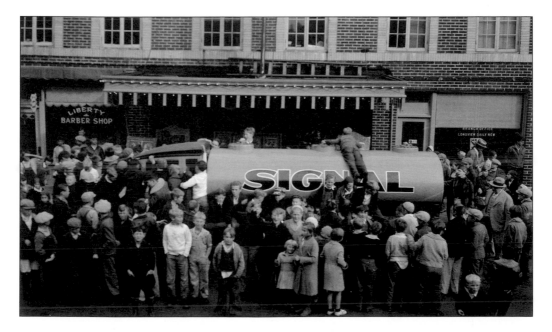

The Lady Maccabees was a popular group for women in the early 1900s, an offshoot of the national fraternal life insurance organization Knights of the Maccabees. Some of the Kelso women pictured in this photograph just prior to the July Fourth parade in 1907 are, in no particular order, Larinda or Merinda Jacobs, Mrs. Rankin, Mrs. Yancy, Mrs. Mitchell, Mrs. Nelson, Mrs. Robinson, Grace Newlson, and Mrs. Towhill. The rest are unidentified.

A Kelso band led a parade of Independent Order of Odd Fellows and other Kelso citizens along South Second Avenue (now South Pacific Avenue) during the July Fourth celebration in 1901. Note the dirt road. In the background to the right is the bell tower of Kelso's Christian Church.

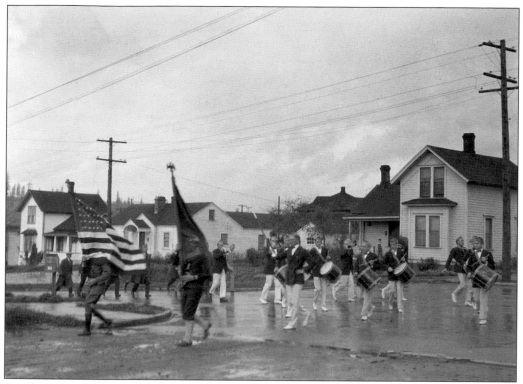

Parades were also held on other occasions in Kelso, as in other cities. Here, a band is shown in the 1926 Armistice Day parade through West and North Kelso. It is a breezy and rainy day, as is typical here in November.

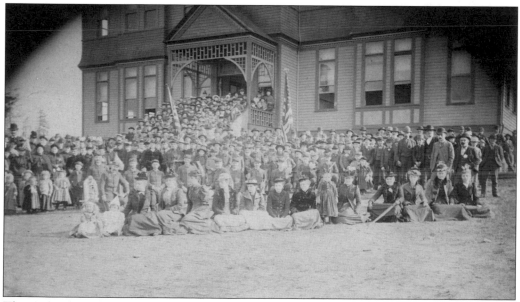

The Columbus Day celebration on October 21, 1892, drew a large gathering in front of the Columbia Street School.

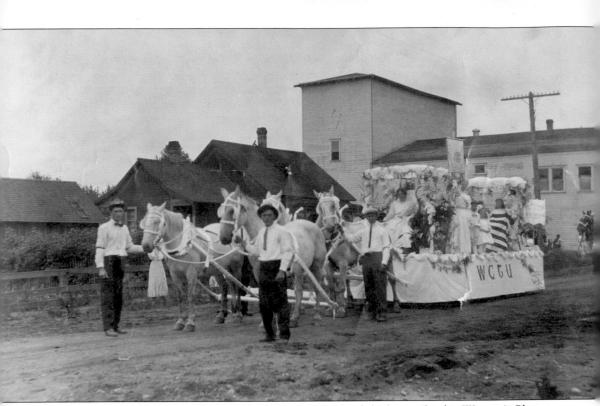

Gus Haussler (front left) and John Jabusch (front right) lead the horses for this Women's Christian Temperance Union (WCTU) parade float on South Second Avenue (later South Pacific Avenue) in 1897. In addition to their efforts to ban alcohol, local WCTU chapters also helped immigrants become naturalized citizens. The large building in the background is McDonough Opera House (later known as Glide Hall), at 703–705 South Pacific Avenue. Opera and vaudeville companies performed there frequently. In the early 1920s, the theater seats were removed, and it was turned into a dance hall and, later, a roller-skating rink. After many decades of use, the building became unsafe and was torn down in 1975.

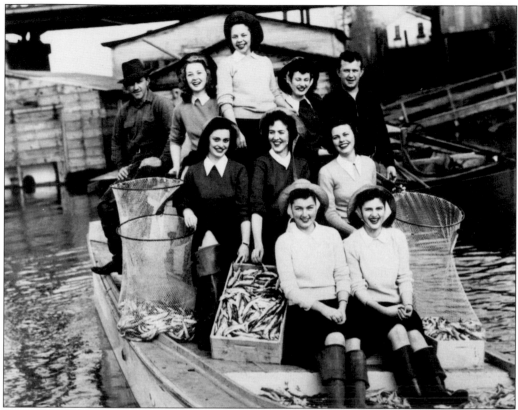

With the arrival of smelt in late winter, it became the custom in the area to select a smelt queen. In this photograph of the queen and her court for 1943 are, from left to right, (first row) Cleo Phillips and Alberta Yaden; (second row) Shirley Hough, Jeanette Foster, and Virginia Harris Soth; (third row) Shirleen Barr, queen Dorothy McCoy, and Betty Lou Melby. The two gentlemen in the back row are Amund (left) and Ervin Taylor.

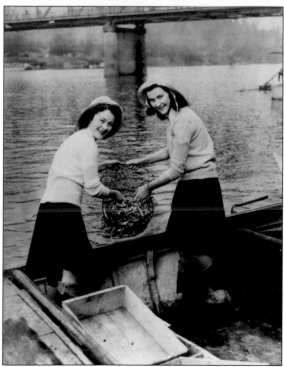

The 1944 Eulachon Queen, Ruby Alexander (left), and court member Lynne Lewis are shown in a boat on the Cowlitz River with a net full of smelt and in the shadow of the Allen Street Bridge. This event became an annual affair until the late 1950s and 1960s. The girls were usually chosen from candidates from Lower Columbia Junior College.

A part of the annual smelt festival in Kelso was a smelt eating contest begun by the Kelso Eagles in 1952. The object was to eat as many smelt as possible in half an hour. In 1972, Quentin Smith of South Bend, Washington, was the winner after eating 85 smelt. He received two trophies and a check for $50—and perhaps some stomach comforters.

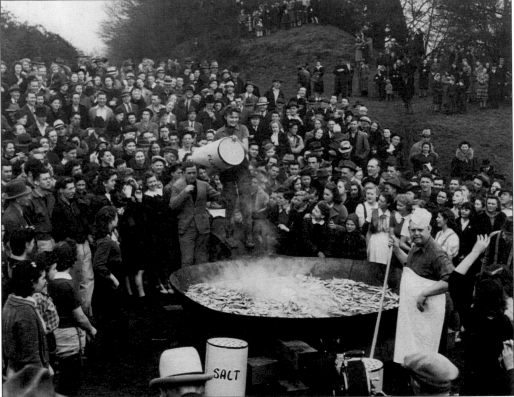

SALT

It was, perhaps, the world's largest frying pan, and it was used to cook a large quantity of smelt for the citizens to eat during a staged smelt fry in 1940 on the shores of the Cowlitz at Sandy Bend (just north of Ostrander). Note the lady about to pour flour into the frying pan. Carlton Moore, a member of the *Kelsonian Tribune* staff and, later, the *Longview Daily News*, is the chef. The event was arranged by *Daily News* editor and publisher John McClelland Jr., seen wearing a suit on the far side of the frying pan.

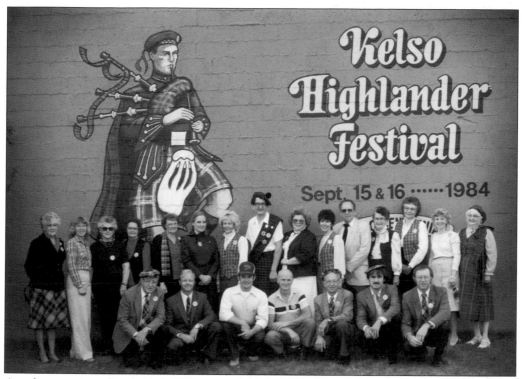

Another very popular event for Kelso was the annual Highlander Festival held in late summer. Most of the people in this photograph are members of Kelso's Centennial Celebration Committee in 1984. They are, from left to right, (first row) Roy Dennis, Larry Peterson, Leonard Cade, Dick Westervelt, George Ott, Randy Trotter, and Mayor Richard Woods; (second row) Peggy Julian, Sandy Reeves, Edythe Gedenberg, Ruth Ott, Marie Dennis, Margot Vaughan, Karen Peterson, Jim Zonich, Jackie Hardwich, Linda Stout, Joe Halleck, Hazel Halleck, Leslie Woos, Joanne Gish, and Camilla Summers.

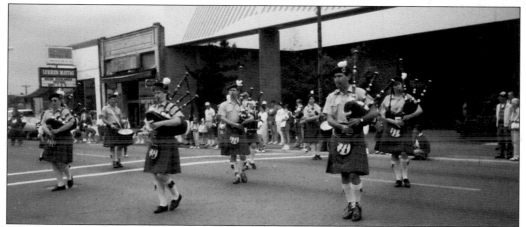

The Highlander Festival is the city's celebration of its Scottish heritage and usually includes a parade with bagpipes, dancing, food, and Scottish games and entertainment. The parade shown is around 1990 and is turning onto Oak Street from South Pacific Avenue. In the background is the old SeaFirst (Seattle First National) Bank Building, which was torn down several years ago to make way for a new city hall.

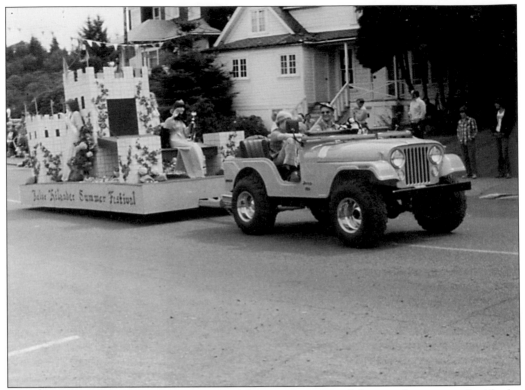

Many types of vehicles pulling a variety of floats were a part of the parade associated with the Highlander Festival.

Five

EXPERIENCING FLOOD, FIRE, WIND, AND MOUNTAIN

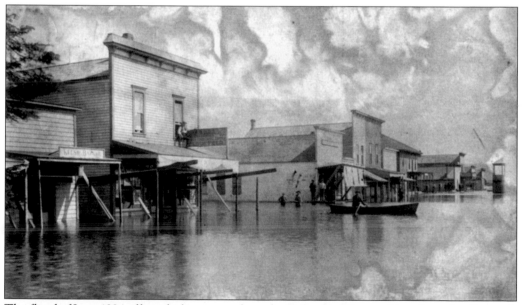

The flood of June 1894 affected a large area along the Columbia River and its tributaries. So much water was flowing down the Columbia River that the flow into it by many large rivers, including the Cowlitz, was backed up. This photograph shows a section of downtown Kelso along First Avenue, looking south. The building on the far left is the Kelso Bazaar, and next to it is the J.B. Hill Grocery, with an unidentified individual sitting in the window. A dry goods and grocery is behind the people standing.

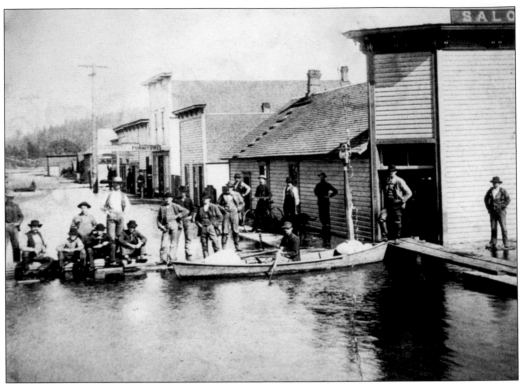

This photograph of First and Allen Streets during the 1894 flood shows the Old Corner Saloon owned by Marcus Swager. A furniture store is two buildings down. John Francis Duggan, father of Jim W. Duggan, is in the boat with flour and household supplies. Marcus Swager, father of Inez Swager Duggan, is directly behind John Francis Duggan. The bicycle belonged to Marcus Swager and was the first bicycle in town. Behind the bicycle is the town marshal, A.M. Barnett. A man called Yancy is standing in the doorway of the saloon.

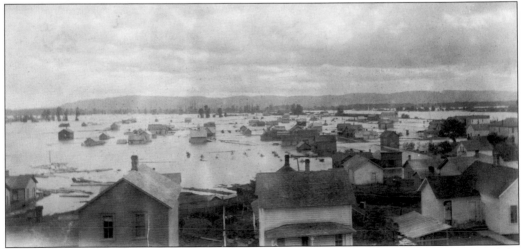

The spring flood of 1894 was due to very warm temperatures and rains in the headwaters of the Columbia River that melted large quantities of snow. With no dikes to prevent the water from entering the city, a large portion of the new town was flooded. This photograph was taken from Fifth and Academy Streets looking south.

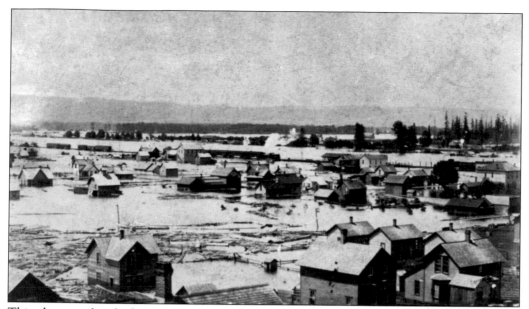

This photograph is looking more west-southwest. Note the flood debris in the lower portion of the photograph and the Cowlitz River running from right to left in the center.

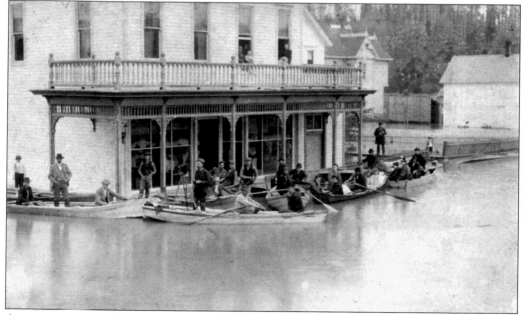

A grocery store was located at the northwest corner of First and Main Streets in Catlin in June 1894. Above it on the second floor was the Odd Fellows Hall. Some of the individuals pictured include Fred Catlin, Johnny Hargrave, C.P. Stayton, and Orin Hinson. Note the man with a tripod camera in the one boat. A portion of what was Nat Smith's home is in the background. That building is still standing in 2011.

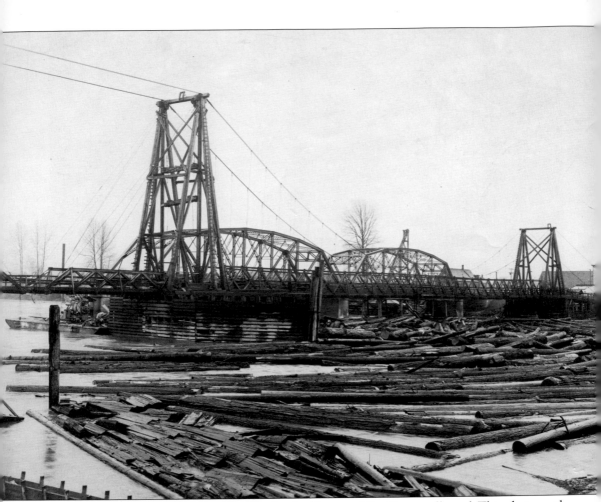

On January 3, 1923, the bridge across the Cowlitz River at Allen Street collapsed. This photograph shows a logjam around the bridge on New Year's Day, which may have contributed to its fall. This was the second Allen Street Bridge, the first having been taken out by a winter storm and high water in November 1906, less than two years after its construction.

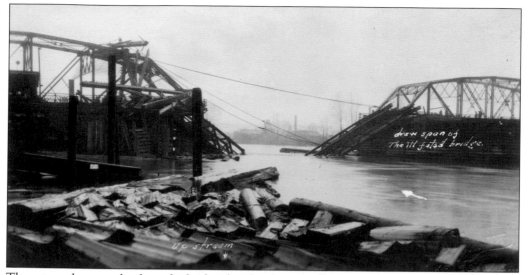

These two photographs show the bridge shortly after its collapse. At the time, a new steel bridge was already under construction immediately downriver from the old one, with only the draw span yet to be completed. Several years previous, planking on the old bridge had been covered over with new boards instead of being replaced, adding extra weight to the suspended span. Before the bridge collapsed, it had been raining hard for several days, soaking the planks through and adding even more weight. Traffic was also heavy on the bridge because a shift at the Long-Bell Mill in newly founded Longview had just changed, and many people were returning to homes in Kelso. As the afternoon of January 3 wore on, the cable on the upriver side of the western span could bear the weight no more and snapped, sending people and vehicles into the cold Cowlitz. Because it was the upriver cable that had snapped, when the bridge hit the water, the current caught it and kept pushing until the collapsed span flipped over, trapping many of those who fell underneath it.

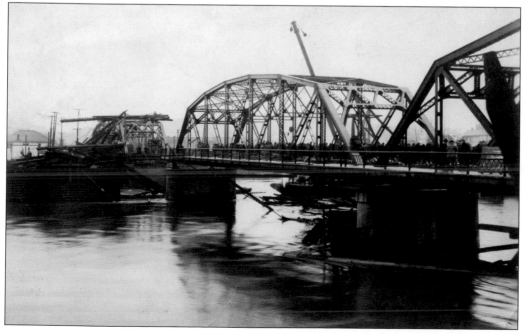

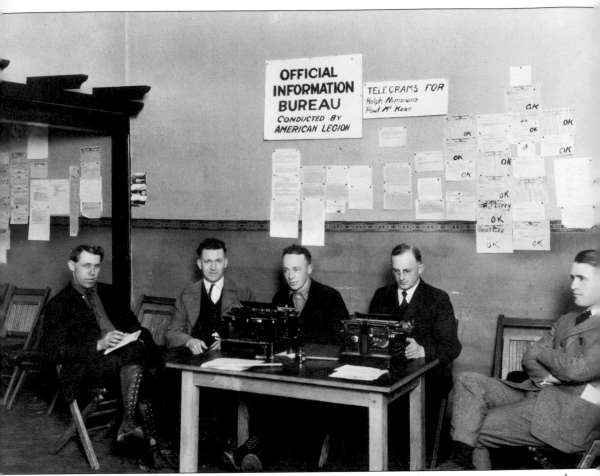

Officially, 17 people died during the bridge collapse in 1923, though many more were reported missing. Immediately afterward, an Official Information Bureau was set up and conducted by the American Legion. The wall behind the gentlemen is posted with telegrams inquiring about individuals who may have been on the bridge during its collapse. The man second from the left is Alex Hay, land agent for the Long-Bell Lumber Company and first post commander for the Longview American Legion. The others are unidentified. The 1923 Allen Street Bridge Collapse was the costliest bridge collapse in terms of lives lost in Washington State history and was the impetus for the beginning of the state's bridge inspection program.

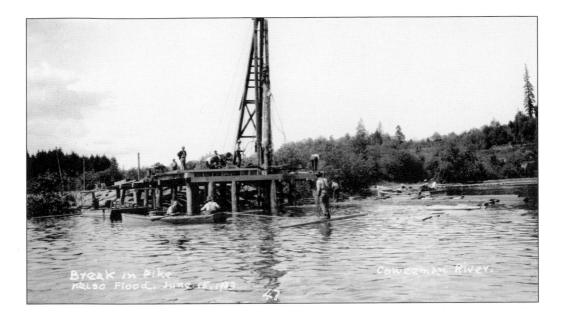

Much of South Kelso was a former slough of the Coweeman River, reclaimed as a residential area by diking in the 1910s (see map, page 9). On June 15, 1933, during a time of high water, the pump house on the Coweeman dike was working at full capacity when the pumps blew, taking the pump house and part of the dike with it. The above photograph shows a crane and timbers erected along the dike to try to repair the breach and stem the flow of the river into Kelso. The below photograph shows the Wallace School located on Elm Street, between South Fourth and South Fifth Avenues. Note the water up to the windows of the school.

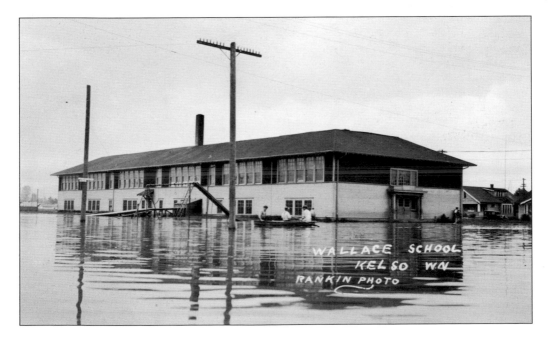

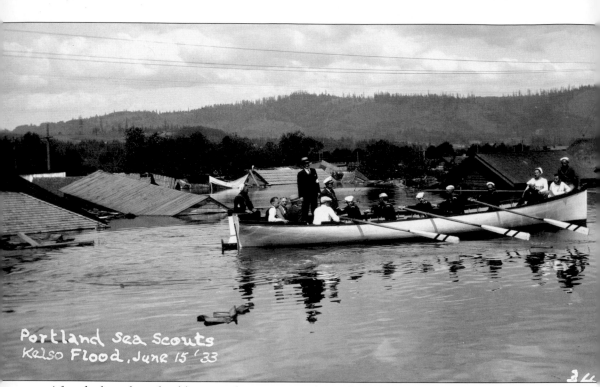

Portland Sea Scouts
Kelso Flood, June 15 '33

After the breach in the dike, water began to spread west from the river, eventually reaching as far north as Oak Street, where it was stopped by a wall of sandbags. Families farther away from the Coweeman had time to move some of their possessions before the river became too high. Other areas closer to the dike were quickly and completely inundated. Water rose to the roofline on many houses in South Kelso during June 1933. Here, the Portland Sea Scouts are shown rowing their skiff by houses to collect stranded people. The area around Mill, Elizabeth, Coweeman, Elm, and Chestnut Streets stayed flooded for almost six weeks until the waters receded.

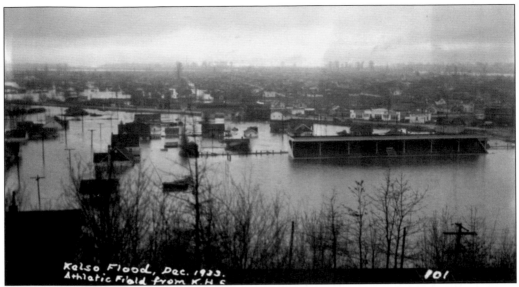

Only six months after South Kelso was flooded in June 1933, another devastating flood struck in late December and put a large portion of the town, and many areas of the Northwest, under water. This photograph, looking south from the Kelso High School on the hill, shows old Schroeder Field and a large portion of South Kelso.

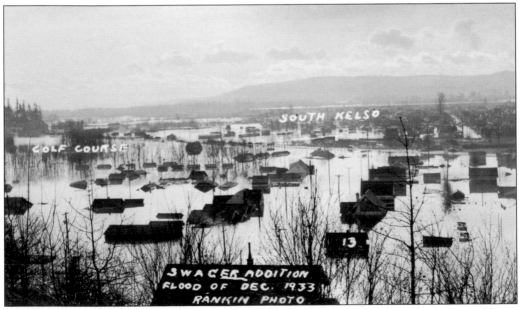

This photograph, looking slightly more southeast than the previous one, shows the Swager addition to Kelso and the golf course to the south—all under water.

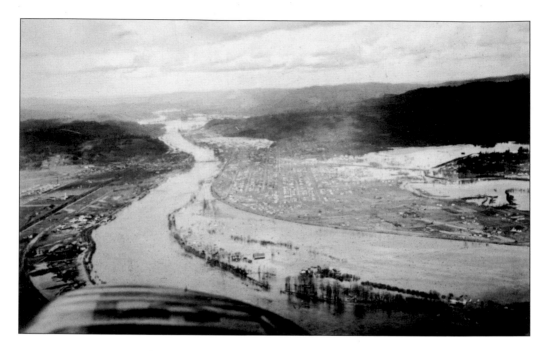

These two aerial photographs show the devastation wrought by the Cowlitz and Coweeman Rivers during the December 1933 flood. The image above, looking north from near the mouth of the Cowlitz, shows the flooding by the Cowlitz to the west of the railroad tracks in South Kelso, as well as the flooding by the Coweeman of large areas of East Kelso (to the right of the photograph). The photograph below, looking east from over the hills north of West Kelso, shows the flooding by the Cowlitz of North Kelso, with the flooded Coweeman in the far right background.

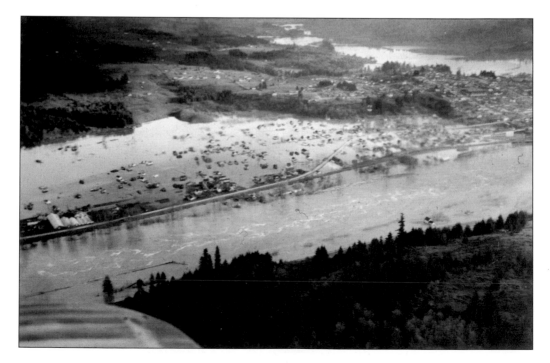

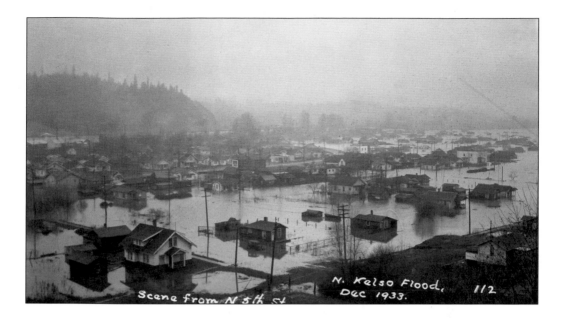

Scene from N 5th st

N. Kelso Flood, Dec 1933. 112

The image above shows the area looking slightly west-northwest from North Fifth Avenue during the December 1933 flood. The Cowlitz River can barely be seen below the hill on the left, near where the Cowlitz River dike broke. The photograph below shows the view southeast from the junior high school, where the Coweeman River has flooded the entire area where Allen Street, Interstate 5, and the Three Rivers Mall are today.

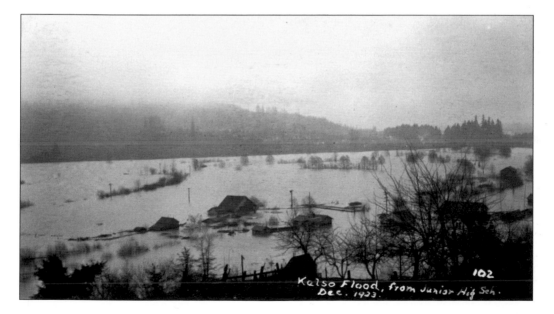

102

Kelso Flood, from Junior Hig Sch. Dec. 1933.

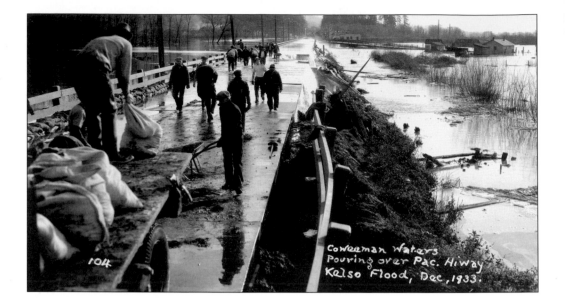

Coweeman Waters
Pouring over Pac. Hiway
Kelso Flood, Dec., 1933.

104

Water from the Coweeman River contributed to the devastation of the December 1933 flood. In the above photograph, a section of the Pacific Highway (now Grade Street) is shown shortly after a portion of the pavement collapsed due to a washout. In the photograph below, essentially the same section of the highway is shown after a temporary board road was constructed.

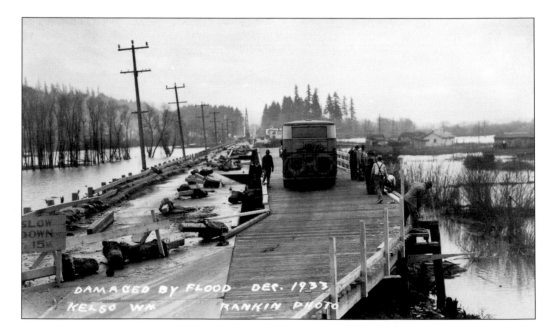

SLOW
DOWN
15 M

DAMAGED BY FLOOD DEC. 1933
KELSO WN. RANKIN PHOTO

During December 1933, the Red Cross set up a temporary shelter in the high school gymnasium where victims of the flood were given food, shelter, and clothing. Three straight weeks of steady, warm rain melted 14 inches of previously fallen snow in the hills and flooded every community in the county except Longview, whose dikes held. December 22 was the worst day of the flood, when Lexington was completely inundated, the dike broke in north Kelso, and the Coweeman River overflowed its banks east of town. Only a massive sandbagging effort overnight into December 23, in the pouring rain and lit by the headlights of trucks, was able to save the Kelso business district.

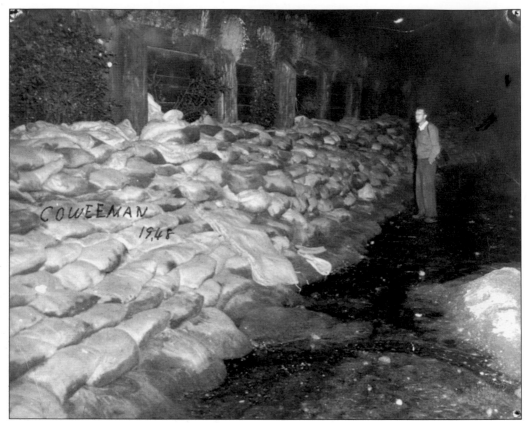

COWEEMAN
1948

Another large flood on the Columbia River in 1948 (known as the Vanport Flood for the area of Portland, Oregon, which was obliterated in it) also disrupted travel in the Kelso area, but not nearly as severely as had previous floods. The photograph above shows sandbags along the Coweeman River dike, while the image below shows US Army amphibious vehicles along the Pacific Highway just south of Carrolls' Bluff. The gentleman at the far left below is Monty Skilling. The Columbia River bottomland south of Kelso was a rich grazing area for cattle, and the many herds pastured there had to be evacuated to higher ground.

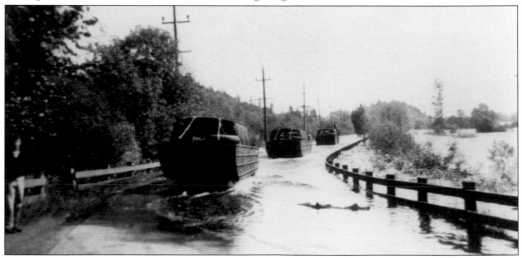

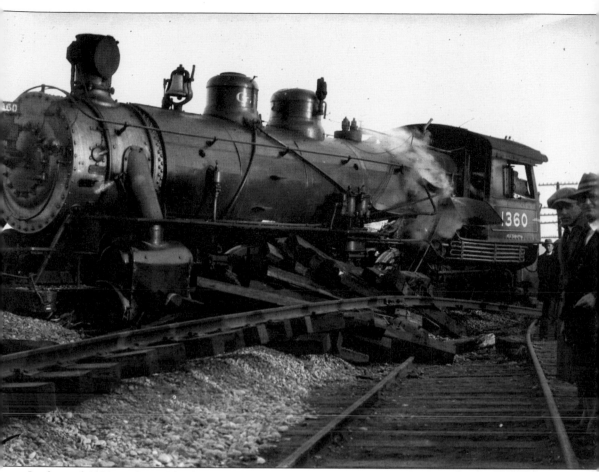

In the mid-1920s, a Great Northern Railroad engine, No. 1360, ran off the tracks in South Kelso at what was known as Krieger's Corner, near where the railroad crossing for South River Road is today. Though several small train accidents have occurred in the area over the years, the worst was a head-on collision of two freight trains between Kelso and Carrolls in 1993, which killed five crew members.

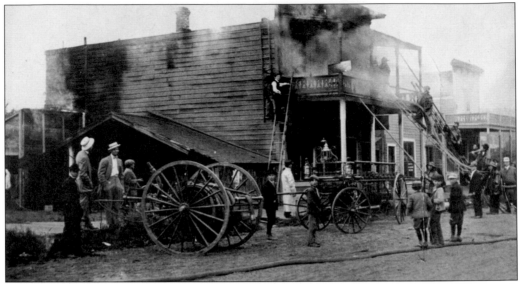

Several large fires have occurred over the course of Kelso's history. This is a 1920 blaze at Springer's Photo located at 213 Oak Street. Several volunteer firemen and bystanders are shown, along with the city's old hose cart.

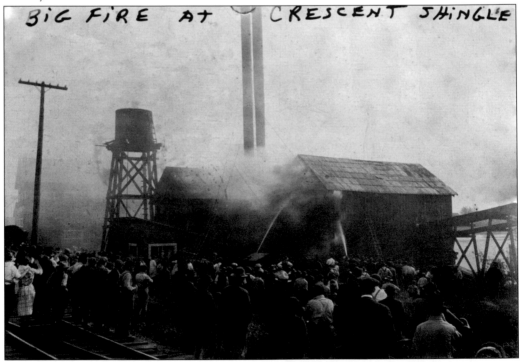

Over the years, several fires occurred at the Crescent Shingle Mill located at the foot of Academy Street. This one occurred in 1923. Shingle mills full of sawdust and wood chips were particularly susceptible to fire, and Kelso's mills suffered their share. No smoking was allowed in the mills, but the occasional spark still flew from the saws and, if not stamped out quickly, could lead to costly losses. The Crescent Shingle Mill burned for the final and most devastating time in 1964 and was not rebuilt.

The fire at the Methodist church at 206 Cowlitz Way on June 1, 1938, was one of Kelso's largest blazes, igniting roof fires more than five blocks away and requiring the assistance of Longview's fire department. The fire may have been caused by electrical wiring in the new church organ. Damage was estimated at $70,000, though insurance only covered $22,000.

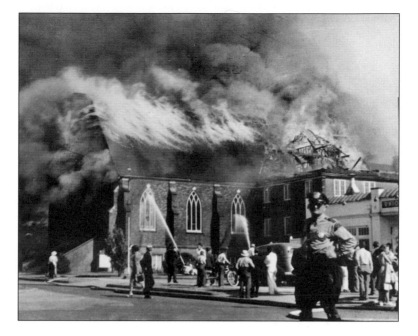

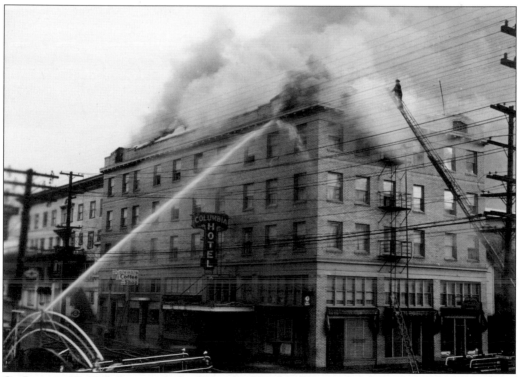

On January 17, 1943, fire struck the Columbia Hotel on the corner of North Pacific Avenue and Academy Street. The fire started in the rear of the first-floor coffee shop and spread upward into the attic space between the fourth floor and the roof. Both Kelso and Longview's fire departments fought the blaze, which caused an estimated $30,000 in damage.

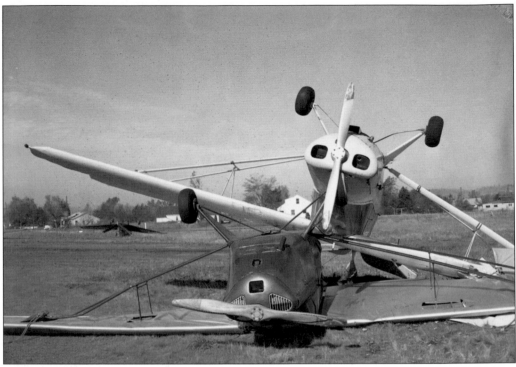

Several windstorms have also wreaked havoc in the Kelso area. The earliest recorded was on June 2, 1894, and affected a large portion of western Washington. The storm may have been a tornado. More recently, on October 12, 1962, the infamous Columbus Day Storm devastated portions of northern California, Oregon, and Washington. It left its mark in the Kelso area, with airplanes overturned at the airport (above) and structural damage to many buildings throughout town, like the city's repair shop on South Pacific Avenue (below), which was blown apart.

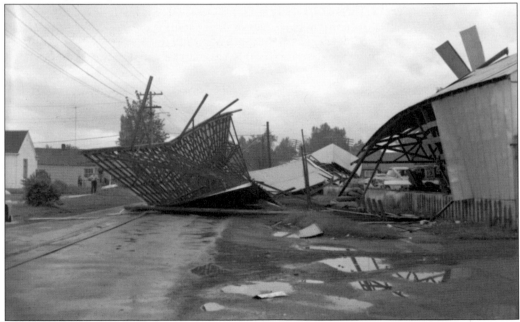

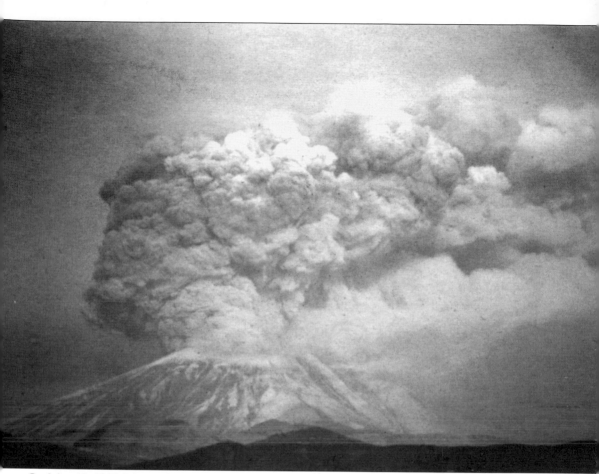

On May 18, 1980, Mount St. Helens blew more than 1,000 feet off its summit after rumbling and spouting ash for several months. The volcano, part of the Cascade Range, sits only 30 miles due east of Kelso. This photograph was taken from the top of Mount Brynion, northeast of Kelso. That day, the wind was blowing from the west, temporarily relieving Kelso of the threat of ashfall.

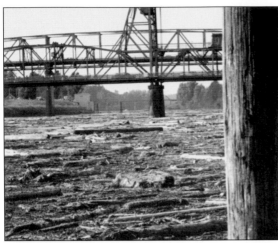

The flooding threat caused by the eruption, though, soon became apparent. Logs, superheated ash, rocks, and debris from the eruption washed down the Toutle River into the Cowlitz River. A portion of that debris can be seen here, near the Allen Street Bridge. The photograph, looking north from the Kelso depot, shows the Railroad Bridge in the distance near Beacon Hill. Many of these logs had already been cut by loggers and were washed out of Weyerhaeuser's Camp Baker on the Toutle River.

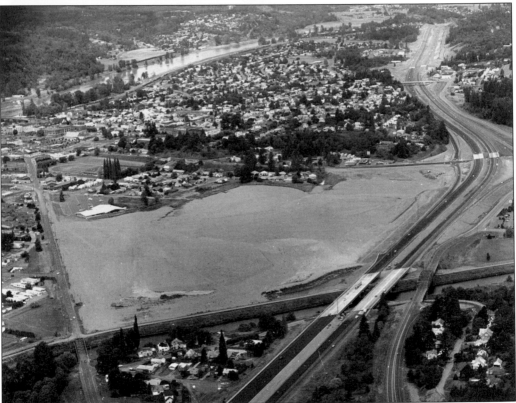

The massive sediment released by the eruption into the area's rivers was a hazard to navigation and to fish runs. If the Cowlitz River had not been dredged to provide a consistent channel, masses of sediment would continue to spill into the Columbia River, quickly filling the deep channel used by oceangoing ships to reach the Ports of Portland and Vancouver. In addition to dredging, sediment dams were built on the upper Toutle River. Some of the resulting dredge spoils were later deposited on the site of the former Elks golf course. This photograph is looking north and shows the area where the golf course was located and where the Three Rivers Mall is today. The Cowlitz River is in the upper left of the photograph, and the Coweeman River is seen in the lower portion of the image.

BIBLIOGRAPHY

Alvord, Rick S., ed. *101 Sports Heroes: Outstanding Sports Figures from the Lower Columbia Region*. Longview, WA: Daily News, 2006.

Christianson, Orpha. *The Long View of the Welfare Program: A Social Worker Looks Back*. New York: Vantage, 1976.

Davis, Dr. Frank. "Autobiography." Unpublished manuscript, 1986.

Frost, Darrell E. "The Evolution of Banking in Cowlitz County, Washington." Master's thesis, University of Washington, 1977.

Jenkins, Don. "Early Town Baseball Rivalries Grew Costly." *Cowlitz Historical Quarterly* 44, no. 2 (2002): 5–25.

Macdonald, J.F. *Macdonald's Steamboats & Steamships of the Pacific Northwest*. Milwaukie, OR: Joemac Press, 2004.

McClelland, John M. Jr. *Cowlitz Corridor*. Longview, WA: Longview, 1953.

McCulloch, Walter F. *Woods Words*. Portland, OR: Oregon Historical Society and the Champoeg Press, 1958.

Moulton, Gary E. *The Journals of the Lewis & Clark Expedition*. Vol. 6., 3rd printing. Lincoln, NE: University of Nebraska Press, 1998.

Summers, Camilla G. *About Kelso, Cowlitz County, Washington*. Longview, WA: Speedy Litho, 1982.

Wilma, Delos D. *Me, Myself, and I: An Autobiography by Delos D. Wilma*. Self-published, 1992.

Wilt, Jessie H. "Splash Dams on the Coweeman." *Cowlitz Historical Quarterly* 29, no. 4 (1977): 16–19.

York, Dorothy and Ruth Ott. *History of Cowlitz County Washington*. Kelso, WA: Cowlitz County Historical Society, 1983.

www.arcadiapublishing.com

Discover books about the town where you grew up, the cities where your friends and families live, the town where your parents met, or even that retirement spot you've been dreaming about. Our Web site provides history lovers with exclusive deals, advanced notification about new titles, e-mail alerts of author events, and much more.

MADE IN THE USA

Arcadia Publishing, the leading local history publisher in the United States, is committed to making history accessible and meaningful through publishing books that celebrate and preserve the heritage of America's people and places. Consistent with our mission to preserve history on a local level, this book was printed in South Carolina on American-made paper and manufactured entirely in the United States.

This book carries the accredited Forest Stewardship Council (FSC) label and is printed on 100 percent FSC-certified paper. Products carrying the FSC label are independently certified to assure consumers that they come from forests that are managed to meet the social, economic, and ecological needs of present and future generations.

FSC
Mixed Sources
Product group from well-managed forests and other controlled sources

Cert no. SW-COC-001530
www.fsc.org
© 1996 Forest Stewardship Council

Find Your Place in History.